D1236952

The Restoration of Christian Culture

JOHN SENIOR

The Restoration
of Christian Culture

IGNATIUS PRESS SAN FRANCISCO

With ecclesiastical approval
© *1983 Ignatius Press, San Francisco*
All rights reserved
ISBN 0–89870–024–8
Library of Congress Catalogue Number 82–83497
Printed in the United States of America

Table of Contents

Acknowledgment

At one of her "final" concerts, a famous soprano
of the last generation said to the faithful audience,
"Your loves have been the wind on which I have
spread these wings of song!" In a little way,
and though this book of lectures is a good deal
less than song, something like that has been true
of the interlocutors and listeners who over the
last five years have called it forth. Some, on
opposing sides of controversies currently dividing
us, might be displeased to find their names linked
here, and of course none is responsible for its
errors, but under pain of plagiarism I must ac-
knowledge those at least who had a direct effect:
among priests, Fathers Charles Taylor, Michael
Moriarty and Harry Marchosky; among former
students, a brave company of religious, Frères
Phillip Anderson, François Bales, François-Marie
Bethel, Lawrence Brown, Joseph-Marie Owen
and, respectfully, their Most Reverend Abbot of
Fontgombault; also to Frère Matthew Shapiro and
his Most Reverend Abbot of Randol; to Brother
Randall Paine, O.S.C., and, loveliest among them,
Soeur Marie-Dolorès Anderson of Jouques; among

seculars, Father Stephen Baxter and seminarians John Cerkey, Paul Coakley, James Conley, James Jackson and David Rabe; among students now teaching, Dr. Robert Carlson and Messrs. Arthur Anderson, Kenneth and Ronald Klassen and James Leek; among colleagues there are two with whom I have conversed so deeply and long I scarcely know which thoughts and words are whose, Franklyn Nelick and Dennis Quinn; I also wish to thank Walter Matt for permission to reprint two essays which first appeared in *The Remnant*; and Father Joseph Fessio, S.J., and his editors at Ignatius Press for their intelligence and care in correcting and restraining an unruly manuscript; and finally I owe a debt of sacrifice to Penelope, Matthew and Andrew; to some unnamed I owe much also, especially one to whom the debt is measureless:

Mulieris fortis beatus vir.

The Restoration of Christian Culture

Mystical Rose, Tower of David, Tower of Ivory, House of Gold, Ark of the Covenant, Gate of Heaven, Morning Star. . . . Why is the Blessed Virgin called these marvelous, mysterious things? Richard of St. Victor, a spiritual master of the Middle Ages, says in a cryptic Latin phrase, *Ubi amor ibi oculus*—"wherever love is, there the eye is also", which means that the lover is the only one who really sees the truth about the person or the thing he loves. It is the perfect complement to *amor caecus est*, another more famous phrase, that "love is blind"—blind to all this lying world because love sees only truth. When a young man loves a girl, we say, "What does he see in her?" But Our Lord said, "Let him who has eyes see." If you love, you will understand. *Ubi amor ibi oculus*. The Litany of Loreto is written in the language of an incomparable love song—St. Bernard called it "the Holy Ghost's masterpiece":

> My sister, my spouse, is a garden enclosed, a foun-
> tain sealed. Thy plants are a paradise of pomegran-
> ates with the fruit of the orchard. Cypress with

spikenard, spikenard and saffron. . . . I am come
into my garden, O my sister, my spouse; I have
gathered my myrrh with my aromatical spices; I
have eaten the honeycomb with my honey; I have
drunk my wine with my milk. Eat, O friends, and
drink, and be inebriated, my dearly beloved. I sleep,
and my heart watcheth: the voice of my beloved
knocking. . . .

This is the language the Blessed Virgin Mary
understands; it is the language of the love of God,
the only one she understands.

I believe, and it is the theme and thesis of
this book, that true devotion to Mary is now our
only recourse. Like many Catholics, I have been
troubled and confused in the fifteen years since
this Dark Night of the Church set in. "I sleep and
my heart watcheth." As an old-fashioned school-
master with the inflated title of professor, I am not
an expert in theology; the point of view through-
out is of an amateur—a lover of religion and not
very religious. It is with a certain reserve that, like
a janitor holding the door, I have urged others
on to rooms I have never myself entered; or like
someone who has studied maps and read descrip-
tions and diaries by travelers to a far country
reporting such marvels as to make this place seem
a *terra aliena*, I have awakened to some deep an-
cestral memory of my native country and its King

Qui vitam sine termino
Nobis donet in Patria.

It is because they have destroyed this love and
longing that the experts fail to see the truth. Any-
thing in motion takes its meaning from the end;
we are creatures in motion and defined by our
desires; what we long for is our truth. Aimless
action self-destructs. It is the story of the Church
and Christian culture in our time.

Theology and its ancillary discipline philoso-
phy are sciences which study ends, and some
of the best minds of the last generation have mis-
takenly thought that they could be the means of
restoration. But sciences abstract from experience;
though thought considered in itself has no en-
vironment, and truth considered in itself is no
respecter of persons, or times and places—still, it
is a particular person who actually thinks in a
particular time and place about what he really
knows. As Chesterton said, insanity is not losing
your reason, but losing everything else except
your reason. The restoration of reason presup-
poses the restoration of love, and we can only love
what we know because we have first touched,
tasted, smelled, heard and seen. From that en-
counter with exterior reality, interior responses
naturally arise, movements motivating, urging,

releasing energies, infinitely greater than atoms, of intelligence and will. Without these motives, thought and action are aimless, sometimes random, more frequently mechanical, having an order but a tyrannical order, that is, an order imposed from without. Christian Culture is the natural environment of truth, assisted by art, ordered intrinsically—that is, from within—to the praise, reverence and service of God Our Lord. To restore it, we must learn its language.

The Blessed Virgin said of her Bridegroom at the instant of the Incarnation, "He brought me into the cellar of wine." The saints who comment on this passage tell us that each of our souls, like hers, must descend with him into that cellar where he will say, "Eat, O friends and drink and be inebriated, my dearly beloved." The saints refer to this as a definite, necessary stage of the spiritual life. Without it, there is no progress toward the Kingdom of Heaven, which is the only goal of the Catholic life, whose only language is music—the etymological root of which means "silence", as in "mute" and "mystery". Music is the voice of silence, and so it follows that to enter with Our Beloved Lord into that prayer of quiet and to pray to Our Blessed Lady that he might lead us there, we must learn to speak that language too, that is we must know music and especially the music

of words which is poetry. No matter what our expertise, no matter what we are by vocation or trade, we are all lovers; and while only the experts in each field must know mathematics and the sciences and other arts, everyone must be a poet in the ordinary way of salvation. As the proper ways of the Catholic life are the province of priests, the ordinary is the province of schoolmasters like myself who from their low vantage, while in the high and palmy ways of science and theology they know little or nothing, know the things that everybody must do first. Oliver Goldsmith says of the Village Schoolmaster,

> In arguing too, the parson owned his skill,
> For even though vanquished, he could argue still;
> While words of learned length, and thundering
> sound,
> Amazed the gazing rustics ranged around;
> And still they gazed, and still the wonder grew,
> That one small head could carry all he knew!

In the revelations at Fatima, Our Lady said more souls are lost to heaven through impurity than any other sin. There are over a million registered murders of unborn children every year in the United States, while a sophisticated pharmacy performs ten million more unregistered ones and calls it contraception, which it is not because

the pills contain abortifacients which dry up the life-supports of tiny children in the first four days of their existence.

Though, so far as I know, it is not a *de fide* dogma of the Church, according to St. Thomas, who cites it as "according to the Fathers", the souls of unbaptized infants inhabit a "place" of perfect natural happiness, eternally deprived of the Beatific Vision, called the Limbo of Children, "for these children have no hope of the blessed life." Of course, he is speaking here of our ordinary presumption in the case; no one knows with certainty the state of any soul except those of the canonized saints; no one knows the unrevealed and extraordinary ways the mercy of God might find. But our moral choices depend here and now on what we know with moral certainty of the ordinary rules, not on what might occur extraordinarily as exceptions. I think the presumption must therefore be that these pills are instruments of a crime worse than murder because they cut the child off not only from life, but from the ordinary means of Salvation.

St. Thomas also says we shall rise on the Last Day at the perfect age of thirty-three. He cites Ephesians 4:13: "Until we meet . . . unto a perfect man, unto the measure of the age of the fullness of Christ." When they walk through the shadow of

that valley on that day, one might imagine how parents who have used the "pill" will feel, face to face with their fully grown children—who will say, "Hello Mom, hello Dad"—lost to Heaven through impurity. We used to think that meant the sinners themselves, which it does; but it is worse than that and far more sad.

But I need not document the crisis in the nation and in the Church. This is to be a positive book, a program for The Restoration of Christian Culture, not an obituary of its death. Indeed I believe it is imprudent to document the disaster quite so much as some of us have. By publishing his achievements you give the Devil more than his due. The question is what can be done—what can and must be done, because there isn't any choice.

Whatever we do in the political and social order, the indispensable foundation is prayer, the heart of which is the Holy Sacrifice of the Mass, the perfect prayer of Christ himself, Priest and Victim, recreating in an unbloody manner the bloody, selfsame Sacrifice of Calvary. What is Christian Culture? It is essentially the Mass. That is not my or anyone's opinion or theory or wish but the central fact of two thousand years of history. Christendom, what secularists call Western Civilization, is the Mass and the paraphernalia which protect and facilitate it. All architecture, art, politi-

cal and social forms, economics, the way people live and feel and think, music, literature—all these things when they are right, are ways of fostering and protecting the Holy Sacrifice of the Mass. To enact a sacrifice, there must be an altar, an altar has to have a roof over it in case it rains; to reserve the Blessed Sacrament, we build a little House of Gold and over it a Tower of Ivory with a bell and a garden round about it with the roses and lilies of purity, emblems of the Virgin Mary—*Rosa Mystica*, *Turris Davidica*, *Turris Eburnea*, *Domus Aurea*, who carried his Body and his Blood in her womb, Body of her body, Blood of her blood. And around the church and garden, where we bury the faithful dead, the caretakers live, the priests and religious whose work is prayer, who keep the Mystery of Faith in its tabernacle of music and words in the Office of the Church; and around them, the faithful who gather to worship and divide the other work that must be done in order to make the perpetuation of the Sacrifice possible—to raise the food and make the clothes and build and keep the peace so that generations to come may live for him, so that the Sacrifice goes on even until the consummation of the world.

We must inscribe this first law of Christian economics on our hearts: the purpose of work is not profit but prayer, and the first law of Christian

ethics: that we live for him not ourselves. And life in him is love. If you keep the Commandments, you will stay out of Hell; if you love God and neighbor as yourself, you will fulfill the law of justice; but the Catholic life is not just staying out of Hell—though that is, to say exactly the least, essential. But the life itself is the Kingdom of Heaven which is to love him and one another as he loves us. St. Thérèse of Lisieux, that ignorant theologian, *scienter nescia*, pointed out that at the first Mass, after Our Lord had distributed his Body and Blood to his first Catholics, he went beyond not only the law of justice but the law of charity. He said to us, "Don't love each other only as yourselves. It is a mystical thing. Love each other as I have first loved you." If we die having kept the law of justice and the law of charity but not this charity itself, we shall spend as much time in Purgatory as it takes to learn it, in terrible pain, such, St. Thomas says, that all the natural pain in the world together is less than an instant of it. I fear sometimes that conservatives, not just liberals, are like the Pharisees—Catholics, but with a strong, unloving determination to be right; whereas the *Camino Real* of Christ is a chivalric way, romantic, full of fire and passion, riding on the pure, high-spirited horses of the self with their glad, high-stepping knees and flaring nostrils, and

us with jingling spurs and the cry "*Mon joie!*"—
the battle cry of Roland and Olivier. Our Church
is the Church of the Passion. Listen to the Holy
Ghost himself, listen to the language in which he
speaks to his Beloved Virgin, the Bride in the
Song of Songs and to our soul:

> I am come into my garden, O my sister, my spouse; I
> have gathered my myrrh with my aromatical spices;
> I have eaten the honeycomb with my honey; I have
> drunk my wine with my milk. Eat, O friends, and
> drink and be inebriated, my dearly beloved.

It is not enough to keep the Commandments,
though we must; it is not enough to love one
another as ourselves, though we must. The one
thing needful, the *unum necessarium* of the King-
dom, is to love as he loves us, which is the love
of joy in suffering and sacrifice, like Roland and
Olivier charging into battle to their death defend-
ing those they love as they cry "*Mon joie*"; that's
the music of Christian Culture. These devils in
the nation and in the Church who murder chil-
dren and disgrace the Bride of Christ can only be
driven out by prayer and fasting. Impurity results
in breaking the Commandments, but in essence it
is a misdirection of love. We shall never drive it
out—all attempts to solve the crisis in the Church
are vain—unless we consecrate our hearts to the

Immaculate Heart of Mary, which means not just the recitation of the words on a printed card, any more than fasting just means eating less, but a commitment to her interior life. We must descend for a certain time each day into the cellar of wine —if he will draw us there—where, alone with him, we are inebriated by his love.

Ubi amor ibi oculus. How shall we see without the eye of love? But how shall we learn to love without love's language? And to learn that language, what is the school? Well, listen to the greatest English schoolmaster:

> If music be the food of love, play on.

Is it difficult to follow the meaning of that? The question is a schoolmaster's to his children, not an expert's to his peers. For lovers, though it might be difficult—in fact impossible—to make a translation into scientific formula, the meaning is clear and strong as good wine. "If music be the food of love. . . ." Reflect a moment on that famous opening line of Shakespeare's *Twelfth Night*—twelfth night of Christmas, written as *ordinary* entertainment for everyone, not for scholars, on the Feast of the Epiphany three hundred and fifty years ago. As the Old Law forbade the eating of all meat animals save ruminants, we should forbid all criticism—which thrives by tearing the

flesh of texts into footnotes and appendices—in favor of an appreciative, ruminating savor of the most ordinary, obvious verse. The best commentary is a similar passage from the same or a similar author. In *A Midsummer Night's Dream*, for example, the King of Music, Oberon, makes something like a commentary on the Duke's opening speech in *Twelfth Night*:

> My gentle Puck, come hither. Thou remember'st
> Since once I sat upon a promontory
> And heard a mermaid on a dolphin's back
> Uttering such dulcet and harmonious breath
> That the rude sea grew civil at her song,
> And certain stars shot wildly from their spheres
> To hear the sea-maid's music.

And Puck replies,

> I remember!

Note carefully what this great master of our culture says about the power of music: that the "rude sea grew civil at her song". "Music is the food of love", ultimately the love of Christ, which gentles the rebellious, rude, savage, sinful heart. You see what it means—that civilization is the work of music. Shakespeare says this again and again. In *The Merchant of Venice* the young lovers step into a garden as a musician plays. It is night; above them, the moon and stars. Lorenzo says,

How sweet the moonlight sleeps upon this bank.
Here will we sit and let the sounds of music
Creep into our ears; soft stillness and the night
Become the touches of sweet harmony.
Sit, Jessica, look how the floor of heaven
Is thick inlaid with patines of bright gold:
There's not the smallest orb which thou behold'st
But in his motion like an angel sings,
Still quiring to the young-eyed cherubins.
Such harmony is in immortal souls;
But whilst this muddy vesture of decay
Doth grossly close it in, we cannot hear it.

This is a reference to the famous theme that all creation sings, that the heavens declare the glory of God, that stars in their courses make a music of the spheres which sounds in harmony with the angels singing *Sanctus, Sanctus, Sanctus* about the throne of God—and that the souls of men have such a music in them too but in "this muddy vesture of decay", that is this worldly exterior life we lead, drawn to the struggles for survival and success, we neither listen nor can hear. The musicians come out into the garden and Lorenzo cries:

Come ho! and wake Diana with a hymn,
With sweetest touches pierce your mistress' ear
And draw her home with music.

In the Song of Songs the Bride cries out, so beautifully in St. Jerome's Latin, *"Trahe me"*—"Draw me!" And Jessica replies:

> I am never merry when I hear sweet music.

A strange response, perhaps. But then it is true, isn't it. Music is deeper than having fun; there is something sad even about the merriest music. Everyone has noted how, for example, in the lightest songs of Mozart, in the comic operas or in his marvelously bright pieces like the Clarinet Concerto, there is an almost unbearable weight, a sadness impossible to hear without tears. Perhaps the most famous example in Mozart is his own use of a lovely love song—*Dove sono*—from his ridiculous comic opera *The Marriage of Figaro*, for the melody of the *Agnus Dei* in his Requiem Mass, which would be thought blasphemous if it were not for the precedent in the duplication of melodies for the Nuptial and Requiem Masses in traditional Gregorian Chant.

Jessica says

> I am never merry when I hear sweet music.

And Lorenzo, the philosopher, explains why:

> The reason is, your spirits are attentive:
> For do but note a wild and wanton herd,
> Or race of youthful and unhandled colts,

Fetching mad bounds, bellowing and neighing loud,
Which is the hot condition of their blood;
If they but hear perchance a trumpet sound,
Or any air of music touch their ears,
You shall perceive them make mutual stand,
Their savage eyes turned to a modest gaze
But the sweet power of music: therefore the poet
Did feign that Orpheus drew trees, stones and floods;
Since nought so stockish, hard and full of rage
But music for the time doth change his nature.
The man that hath no music in himself,
Nor is not moved with concord of sweet sounds,
Is fit for treasons, stratagems and spoils,
The motions of his spirit are dull as night,
And his affections dark as Erebus:
Let no such man be trusted. Mark the music.

Our Lord explains in the Parable of the Sower that the seed of his love will only grow in a certain soil—and that is the soil of Christian Culture, which is the work of music in the wide sense, including as well as tunes that are sung, art, literature, games, architecture—all so many instruments in the orchestra which plays day and night the music of lovers; and if it is disordered, then the love of Christ will not grow. It is an obvious matter of fact that here in the United States now, the Devil has seized these instruments to play a *danse macabre*, a dance of death, especially through

what we call the "media", the television, radio, record, book, magazine and newspaper industries. The restoration of culture, spiritually, morally, physically, demands the cultivation of the soil in which the love of Christ can grow, and that means we must, as they say, rethink priorities.

What I suggest, not as the answer to all our problems, but as the condition of the answer, is something at once simple and difficult: to put "the touches of sweet harmony" back into the home so that boys and girls will grow up better than we did, with songs in their hearts; so that, singing the old songs all their lives, they may one day hear him sing the Song of Songs:

> Arise, make haste, my love, my beautiful one, and come. For winter is now past, the rain is over and gone. The flowers have appeared in our land, the time of pruning is come: the voice of the turtle is heard in our land. The fig tree hath put forth her green figs; the vines in flower yield their sweet smell. Arise, my love, my beautiful one, and come.

I fear no girl will ever hear that song again from some young man in the spring of her life whom she might marry, or boy or girl, in the autumn, from Christ.

First, negatively, smash the television set. The Catholic Church is not opposed to violence; only

to unjust violence; so smash the television set. And, positively, put the time and money you now spend on such entertainment into a piano so that music is restored to your home, common, ordinary Christian music, much of which is very simple to play. Anybody can learn the songs of Stephen Foster, Robert Burns, the Irish and Italian airs, after even a few hours' instruction and practice. And then families will be together at home of an evening and love will grow again without thinking about it, because they are moving in harmony together. There is nothing more disintegrating of love than artificial attempts to foster it at encounter groups and the like: Love only grows; it cannot be manufactured or forced; and it only grows on the sweet sounds of music.

The most important kind of music in the wide sense, meaning all the cultural faculties, is, of course, the music of words—that is, poetry and literature. Music in the strict sense of song and instruments plays an enormous part in shaping the sensibilities, so does art; but what you read enters directly into the intelligence and has therefore an even stronger effect. We must put our greatest effort into restoring reading in the home, first and foremost reading aloud around the fireplace of a winter's evening or on the porch of a summer's

afternoon; and for the older children and adults, silent reading, each by himself as they all sit together in the living room, reading, not the hundred great books which are for analytic study and mostly for experts, but reading what I shall call *the thousand good books*, not everyman's but everychild's library, the ordinary stories and poems we all should know from Mother Goose to Willie Shakespeare, as she affectionately calls her best friend, the thousand good books for children in the nursery to the youth at college, which we read and reread all the rest of our lives.

But first, you cannot be serious about the restoration of the Church and the nation if you haven't the common sense to smash the television set. You often hear it said television is neither good nor bad; it is an instrument like a gun, morally dependent on the motive for using it, not as the moralists say *per se* evil but only accidentally so, which is true; but concrete situations are *per se* accidental! There is a mean between *per se* and accidental called the determinant, which means what happens so many times and/or so intensely as to determine an outcome. It is usually the general, as opposed to the universal on the one hand and the particular on the other, which determines; but sometimes the determinant factor is a minority or even, though very rarely, a single

case. Television is both generally and determinantly evil—not just accidentally so. It is not a matter of selecting the best programs, influencing producers and advertisers or starting your own network. Its two principal defects are its radical passivity, physical and imaginative, and its distortion of reality. Watching it, we fail to exercise the eye, selecting and focusing detail—what poets call "noticing" things; neither do we exercise imagination as you must in reading metaphor where you actively leap to the "third thing" in juxtaposed images, picking out similarities and differences, skill which Aristotle says is a chief sign of intelligence. So television is intrinsically evil, though it is obviously extrinsically so as well. There is nothing on television not filtered through a secular establishment. "How wonderful to see the Pope!" But you didn't see the Pope. You saw commentators interpreting the Pope through their media, not only by commentary but by selection and angle of the shots. A theologian once said to me when I complained about the distribution of Communion by laymen, "I'd receive Communion from the Devil if that's the only way I could get it!" I think he was wrong. I'd hold with Newman who said of a similar situation that he "would wait for better days". If I want to see the Pope, I'll go four thousand miles to Rome; but I shall not

receive him from the hands of CBS. The whole of television is misdirected because its managers are not just non-Christians but anti-Christians. It is not just the obviously bad programs but the deceptively educational ones which are managed with the same end in mind—which is nothing less than the extirpation of Christ from culture by excision and distortion. Even if a particular sequence or shot, a sports event or vaudeville act, for example, isn't in itself so bad, the context is, and the context determines. Worse, as I said, because more insidious, is the unreality. "My football game!" the old man cries. But here you touch not only on television but the professionalization of sports where the armchair quarterback, puffing his gut on insipid American beer and potato chips, gapes like Nero at his gladiators hacking each other up, while his neglected children take up punk rock on their car-cassettes. If you really like football, get out on Saturdays and play it with the boys.

I realize how like ranting this must seem—too much, too fast and against the grain. But stereo and hi-fi sets substitute for sense, imagination and reality as well. And don't be fooled by high-class record collections of all the arty best from Gregorian Chant to Aaron Copland. Gregorian Chant is solemn prayer and must never be treated

as music for one's "listening pleasure", as they say; and Copland is kitsch. It is not just the worst of the drug stuff and the pornography, but the high-class, ritzy culture of the New York Philharmonic and the multi-microphoned Met, which mixes modernistic interpretations of the classics in electronic blenders where it is interspersed with sophisticated disharmonies intrinsically designed for the self-destruction of music and the ruination of all normal habits of tonal differentiation—I mean the best of disordered genius like Stravinsky's and Mahler's, not to mention self-promoted frauds like Schoenberg. And though it would take too long to digress, electronic devices are not only evil in their misdirection of the end, but in the very means themselves they are destructive, as television is, of imagination and sensibility. Electronic reconstitutions of disintegrated sounds are not real sounds any more than reconstituted, sterilized lactates are milk. The greatest pianist of the last generation, Joseph Hoffman, refused to make records because he said it horrified him to think someone could clone a single performance, iterating it over and over; whereas in concerts he struck each note fresh as if for the first time. As extreme and fanatical as it may sound, I risk the charge and repeat as quietly and seriously as I can, that, negatively, we must rid our homes of these

mechanical and electronic devices and, positively, restore real, live, simple, homely, Christian music and literature to the living room in their rightful place. I know it is unpleasant to be chided; it is always more cheery to hear the prophet when he denounces the other Philistines across the street; as Cardinal Newman says, the preacher goes too far when he carries things home to ourselves! Well, it is simply so. Catholics have accepted some of the worst distortions of their Faith in the order of music, art and literature without a shiver of discontent because they never really heard the "Tantum ergo" or the "Ave maris stella"—not for lack of faith, but because there had never been ordinary music in the home to have created the habit of good sound and sense.

And as for reading in the home; it isn't done at all. The Great Books movement of the last generation didn't so much fail as fizzle, and not because of any defect in the books; they are the "best that has been thought and said", in Matthew Arnold's famous phrase; but like champagne in cracked bottles, the books went flat in minds which lacked the habit of reading. To change the figure, the seeds grew but the cultural soil had been depleted; the seminal ideas of Plato, Aristotle, St. Augustine, St. Thomas, only properly grow in an imaginative ground saturated with

fables, fairy tales, stories, rhymes, romances, adventures—the thousand good books of Grimm, Andersen, Stevenson, Dickens, Scott, Dumas and the rest. Western tradition, taking all that was the best of the Greco-Roman world into itself, has given us a culture in which the Faith properly grows; and since the conversion of Constantine that culture has become Christian. It is the seedbed of intelligence and will, the ground for all studies in the arts and sciences, including theology, without which they are inhumane and destructive. The brutal athlete and the aesthetic fop suffer vices opposed to the virtues of what Newman called the "gentleman". Anyone working in any art or science, whether "pure" or "practical", will discover he has made a quantum leap when he gets even a small amount of cultural ground under him; he will grow like an undernourished plant suddenly fertilized and watered.

And the right point of view is that of the amateur, the ordinary person who enjoys what he reads, not expert in critical, historical or textual techniques which destroy what they analyze and are as inimical to culture as sex-clinics to marriage or scientific agriculture to farming. Whatever you do, don't poison the wells and salt the fields with dictionaries, encyclopedias, atlases, study-guides, critical editions, notes, biographical and historical

appendices—all of that is the science of literature; it is a misapplication of scientific method to a subject matter outside its competence. We want what Robert Louis Stevenson called "a child's garden", something simple, direct, enjoyable, unreflective, uncritical, spontaneous, free, romantic, if you will, with the full understanding that such experience is not sufficient for salvation, as the Romantic School thought, nor sufficient for science and philosophy, but indispensable as the cultural soil of moral, intellectual and spiritual growth. And so instead of an argument, I propose a reading of the thousand good books.

Because sight is the first of the senses and especially powerful in the earliest years, it is important to secure editions illustrated by artists working in the cultural tradition we are restoring, both as introduction to art and as part of the imaginative experience of the book. This is not to disparage all contemporary artists any more than the tradition itself denies experiment; quite the contrary, one of the fruits of such reading should be the encouragement of good writing and drawing by the reader. A standard is not a strait jacket but a teacher of norms and a model for imitation. Book illustration reached its classical perfection in the hundred years before World War I in the work of "Phiz", Gordon Browne, the Brock brothers,

Beatrix Potter, Sir John Tenniel, Arthur Rackham, Howard Pyle, N.C. Wyeth, Randolph Caldecott, Walter Crane, Kate Greenaway, George Cruickshank, Leslie Brooke and many others. The rule of thumb is to find an old edition in a secondhand shop or at least facsimiles which though not as sharp in line or true in color are available at more moderate prices.

For English-speaking Catholics there is a difficulty which would take a whole treatise to deal with adequately: English literature is substantially Protestant. It is all well and good to quote St. Paul that "whatever is true is from the Holy Ghost" and argue that this literature, whether Protestant, Jewish or Infidel, so long as it is true, is Catholic despite the persuasion of its authors. All well and good provided that literature were abstract science; a matter of two and two are four. But literature by definition is that paradoxical thing the "concrete universal", imitating men in action in their actual affective and moral and spiritual struggles. And so Catholics have to live with a difficulty. The thousand good books which are the indispensable soil of the understanding of the Catholic Faith and indirectly requisite to the Kingdom of Heaven, are not Catholic but Protestant.

The recognition of this has led some well-meaning Catholic teachers to the recommenda-

tion of texts and reading lists of strictly Catholic authors, which can only be done by supplying large amounts of Latin, French, Italian and other foreign authors in translation along with those very few Englishmen who happened to be Catholic and alas, though by no means bad, are all second-rate. No matter how you do it, the attempt is hopeless. First, we are English-speaking people. Our language is English and if we are to learn it, we must absorb its own peculiar genius. If we are to have English Catholic authors or even readers, they must be schooled in the English language as it is, and not in even the best work of translators, who are not men of genius, no matter how great the works they are translating. Dorothy Sayers, for example, is a fine Christian lady, I am told, and the Italian Catholic Dante is one of only three candidates for the title of greatest poet who ever lived; but Dorothy Sayers' translation of the *Divine Comedy* is something of a comedy in another sense and not even remotely in a class of excellence with the Puritan Latin Secretary to the arch-heretic and murderer of Catholic Ireland, John Milton, or even with the atheist Irish sympathizer Shelley, whom Miss Sayers imitates in attempting —disastrously—Dante's *terza rima*. English litera-ture is not an option; it is a fact. And it is Prot-estant; we are at once blest and stuck with it—blest

because it is the finest literature in the world, and stuck because it cannot ever be done again.

Catholic parents and teachers must read and re-read Cardinal Newman's long, balanced, incomparable essay on the whole subject, "Catholic Literature in the English Tongue", in his *Idea of a University*.

The upshot of the difficulty is that the heart, indeed, the very delicate viscera, the physical constitution and emotional dispositions as well as the imaginations, of children will be formed by authors who are off the Catholic center and some very far off; and yet, not to read them is not to develop these essential aptitudes and faculties.

Having stated the facts first as a difficulty, I hasten to add that it is a difficulty we can live with and flourish under. First of all, insofar as the literature is Protestant, it is Biblical and Christian; the existence of God, the Divinity of Christ, the necessity of prayer and obedience to the commandments is its very strong stuff for the most part and there is little anywhere in direct violation of the Catholic Faith, though there is some overt, sometimes crude, sometimes true, accusation. Since Protestantism stands in between its Catholic and Jewish antecedents in a kind of Hebraic Christianity, at least in its Calvinist tendencies, its popular literature has been both anti-Catholic and anti-

Jewish. Charles Kingsley's *Westward Ho!*, one of
the best boys' books, is filled with outrageous
lies about the Jesuits; and both Shakespeare and
Dickens, with Shylock and Fagin, have exploited
and exaggerated the avarice of the Jews. But what
Chesterton said of *Westward Ho!*—"It's a lie, but
a healthy one"—could be said of *A Merchant of
Venice* and *Oliver Twist*. It is the unhealthy phari-
saical Catholic and Jew who resent the caricatures
of themselves. The health and excellence of carica-
ture always consists in its accidental prevarication
of essential truths. The fact is that Jesuits have
sometimes been a scandal, despite the glorious
Company of their saints; and Jews have been
conspicuous usurers, pornographers and Com-
munists, despite their large courage in the face of
unjust persecution and the smaller company of
converted saints. Good Catholics and Jews can
laugh and weep at once at the truth in these car-
toons, just as a temperate Irishman—if you can
find one—would laugh and weep at the stage Irish
drunk, or an honest Italian, at the Godfather.

 One of the most famous and best of geniuses
in the list of classical children's books is not
an English Protestant but some kind of French
Catholic. By the time you finish *The Three Mus-
keteers* it is clear enough that sin is punished.
Aramis, who had played his part in satirizing

religious vocations early on in the novel, actually becomes a monk at last—albeit in a sequel not a very good one! There is one lurid scene in which D'Artagnan, the golden boy and best of heroes, commits explicit and rather preposterous adultery under sensational conditions with the most fatal *femme fatale* in literature; but both participants suffer the consequences, she a horrid death and he a harrowing education. Perhaps *The Three Muskateers* is best reserved for the older end of the adolescent spectrum, around sixteen; but taken all in all, it is an adolescent book and the paradigm of dashing derring-do, and it is good—I mean morally good. Like it or not, the kind of adventure you get in Alexandre Dumas is there in literature as the Rocky Mountains are there in geography. You might have got to California quicker if they weren't, but getting there was "half the fun" in the one case; and the chivalry, intrigue and romance is all the fun in the other.

The worst failure in English classical literature is indirect, that is its omissions—the conspicuous absence of Our Blessed Mother and the Blessed Sacrament and, following from the loss of these principal mysteries, all the rich accidentals of Catholic life, the veneration of saints and relics, the use of medals, scapulars, holy water, Rosaries. When these are present, which is rare, it is usually,

alas, to disparage them as superstition—though not always; for example there is the tender scene in *Little Women* where the French servant explains the Rosary to the incredulous but amazed and edified little Amy. But no doubt about it, the omissions are a great disappointment and must be compensated for by daily use of these instruments and by a rich, Catholic and especially Latin liturgical life. From the cultural point of view, which I must insist is not a minor or accidental thing but indispensable to the ordinary means of salvation, and prescinding from all the complex canonical and theological disputes about its validity and liceity—whatever defense can be made of it on pastoral and other grounds—from the cultural point of view, the new Catholic Mass established in the United States has been a disaster; and I must give public witness to my private petitions, with all due respect to the authorities, that its great predecessor—the most refined and brilliant work of art in the history of the world, the heart and soul and most powerful determinant factor in Western Civilization, seedbed of saints —be restored. Catholic children brought up on the best English literature must at the same time be immersed in the traditional Catholic practices like Rosaries, Benedictions, Stations of the Cross. And when there is explicit disparagement of any-

thing Catholic in the literature, the parent and teacher must censor it—not with the scissors, which is impossible because these things are too intimately connected with the context—but by explanations. For younger children the parent or sister who reads the stories aloud can correct misunderstandings tastefully in quiet conversation, using the errors themselves as occasions to teach the truth—sometimes the truth that Catholics have not lived up to their Faith. For the school child, teachers can use distortions and caricatures as a stimulus for further reading; Kingsley's violence to the Jesuits, for example, can be an occasion for a child to read the lives of St. Isaac Jogues and his companions and other missionary saints. For the adolescent and youth, his own strength in the Faith should be sufficient; anti-Catholic texts should provide a kind of test of his understanding, and teachers can conduct colloquia to bring the questions out.

But I have belabored the point too long. In the hundreds of thousands of pages of the thousand books, the number of passages calling for such correction are very few. The chief difficulty, as it is of modern culture in general, is the lack of those ordinary Catholic accidentals determinant to Faith; and these must be restored in the Church and at home. Actually, since we are English-

speaking people, living in a non-Catholic sub-culture, it is good for a Catholic child to grow up with an imaginative grasp of the hostile environment—short, of course, of anything pornographic, ironic and sly, and there is none of that in the classic children's literature; all in a common sense way are "good", artistically, morally and spiritually, though they are not complete.

Perhaps there is a need for just one further caution on adolescent reading: Here you are dealing with a time of life which is by definition dangerous. "Adolescent" comes from a Latin word meaning "to burn", and it is certainly a burning age. The literature of adolescence, say, Shakespeare's *Romeo and Juliet*, sometimes overheats an excitable imagination; those star-crossed lovers fall desperately and hotly in love, and it may well be that the reading of certain of its best passages could lead young people into sin, like the wretched souls in Dante's *Inferno* who blame their eternal damnation on the reading of an Arthurian romance. "A *galeotto* was that book", Francesca says—*galeotto* is an Italian word for pimp. There is no question that adolescent reading must be accompanied by strict, serious, complete dogmatic and moral teaching and by a strong, active, vigorous, rigorous gymnastics program. But a severe warning is in order for Catholic parents who, the

more conservative they are in their Faith, tend toward a Jansenism in their discipline of children. When a child hits twelve, he is ready for the adolescent experience, and that means the explosions of physical aptitudes and the emotional responses to them—the call to dangerous adventures and to experiments in romance. There is a certain kind of parent who wants to bind a child's soul the way the Chinese are said to have bound their little girls' feet to keep them dainty. There are Catholic families who proudly send their eighteen-year-olds up to college carefully bound and wrapped at the emotional and spiritual age of twelve—good little boys and girls in cute dresses and panty-waists who never get into trouble or into knowledge and love. The Kingdom of Heaven is the knowledge and love of God, and we learn to bear the living flames of that love only through suffering the paler heats of human desire; and adolescence is as necessary to the normal development of the body and soul as the Faith itself. Faith presupposes nature and cannot be efficacious in its atrophy. There is little point in keeping children out of Hell if you don't afford them the means of getting into Heaven.

So give them solid catechetics, strong preaching, good example, healthy exercise, supervision in a general and determinant way but not in each

particular and by all means permitting them the freedom of the good, dangerous books as well as the dangerous games such as football or mountain climbing. Given the state of man, some will break their necks and sin; but in good Catholic families with common sense, the falls should be few and the bodies and souls recoverable. The positive power of the literature and the games is so good and great that we must thank God English literature and sport have been so richly blessed, though we sometimes, as we shouldn't, grudge the genius of those marvelously gifted Protestants, some of them even terrible Protestants like John Milton!

Fortunately, for the most part, the majority of the authors are sympathetic to the Faith and some, like Shakespeare, may even have been *in pectore* Catholic. Dickens had a visionary dream he took very seriously of the Virgin Mary who instructed him to write more warmly of Catholics, which he did in one of his greatest novels, *Barnaby Rudge*. Despite the revisionist historians, the past is past and cannot be changed. If you dispense with the classics, you lose the culture—and whatever the culture is, it is ours, still in its roots and in its truth, goodness and beauty, Catholic.

To conclude not so much with a proof of anything as an exhortation to experiment: Read, preferably aloud, the good English books from

Mother Goose to the works of Jane Austen. There really is no need for reading lists; the surest sign of a classic is that everyone knows its name. And sing some songs from the golden treasury around the piano every night. Music really is the food of love, and music in the wide sense is a specific sign of the civilized human species. Steeped in the ordinary pot of the Christian imagination, we shall have learned to listen to that language by absorption, that mysterious music the Bridegroom speaks; and we shall begin to love one another as he loves us; we shall see at last the Star of Hope which "flames in the forehead of the morning sky" at the end of this dark night. We shall see, because we love—*Ubi amor ibi oculus*—though not without her help: *Rosa Mystica*, *Turris Davidica*, *Domus Aurea*, *Stella Matutina* . . . Morning Star.

CHAPTER II

The Air-Conditioned Holocaust

When someone said to the famous film producer, "You can't take it with you, Sam", Sam replied: "In that case I'm not going." But he went. All of us do—the lean, the fat, the fickle, faithful, unfulfilled and satisfied. And the moral of the tale is this: Some things are not a matter of our making them so, like movies, money or the social sciences; some things are objectively certain, like death and taxes.

Someone has to pay the price of everything; everything of value has a price. Not even the air we breathe is free. There is a general tax, like a valence, on everything that lives and moves and has its being. The tax on every life is someone's death because nothing of value can be won without sacrifice. In nature everything which feeds on anything is food in turn for something else, even—what a scandal to our self-esteem!—even us. As Hamlet says,

> A man may fish with the worm that hath eat of a King, and eat of the fish that hath fed of that worm [which proves] how a King may go a progress through the guts of a beggar.

All philosophy, said Socrates, is "a meditation on death." The tragic poets, and most of the comic ones, are full of pessimism because they see the certainty of death. If it is true, they reason, that everyone must die, then what is the purpose of life?

> Golden lads and girls all must
> As chimney-sweepers come to dust.

And if you suggest that life goes on in our children, through the generations, which is a kind of immortality, the poets reply: That doesn't answer the question; it merely postpones it. What do all the generations come to at the end? The whole human race, taken all in all, exists for the length of a few pulsations of some star between the closing valves of evolutionary extinction. The whole thing altogether really is, as Macbeth said, "A tale told by an idiot . . . signifying nothing", or Solomon, "Vanity of vanities, all is vanity."

Well, if life is meaningless, we can rationally conclude to this bitter resignation of the tragic poets or, like the comic ones, cry "Eat, drink and be merry, for tomorrow you will die!" These are the complementary-opposite responses of rational pessimists. Others concluding to the same pessimism, have irrationally refused to accept it, attempting to construct an artificial universe of their own in death's despite, an Earthly Paradise in

which there is no death or taxes—and this is what technology has tried and bitterly failed to do; after five hundred years of spectacular success, it has reduced our lives to *nothing but* death and taxes!

The Nobel laureate chiefly responsible for the mathematics behind the computer, Bertrand Russell, has written the most popular and precise summation of the technological view in his famous essay, "A Free Man's Worship":

> That Man is the product of causes which had no prevision of the end they were achieving; that his origin, his growth, his hopes and fears, his loves and his beliefs, are but the outcome of accidental collocations of atoms; that no fire, no heroism, no intensity of thought and feeling, can preserve an individual life beyond the grave; that all the labours of the ages, all the devotion, all the inspiration, all the noonday brightness of human genius, are destined to extinction in the vast death of the solar system, and that the whole temple of Man's achievement must inevitably be buried beneath the debris of a universe in ruins—all these things, if not quite beyond dispute, are yet so nearly certain, that no philosophy which rejects them can hope to stand. Only within the scaffolding of these truths, only on the firm foundation of unyielding despair, can the soul's habitation henceforth be safely built.

The poets and technologists, pessimists and optimists, so superficially opposed, beneath the surface

are of one compact: they are agreed about the radical insignificance of life.

Of course there is another view altogether that life is neither insignificant nor doomed. There are those like Socrates, Plato, Aristotle and the tradition of Christian thought whose meditation on death begins with an acknowledgment of the obligation of taxes, which, they say, explains death in a just and satisfactory way: If the price is paid, they say, the goods are fairly got. Socrates believed there is a final justice in another world beyond death, a Kingdom of the Good, the Beautiful and the True; the universe, he thought, is ultimately good; and he gladly went to his death as to a sacrifice where one pays the just tax on immortality, which is the significant death of a just man.

There is a Christian remnant living in Hope even today; but generally speaking, the modern world is divided between literary pessimists and technological optimists who are really pessimists in the long run. Some with comic masks on, like Gustave Flaubert, laugh in bitterness at the silly hopes of Christians whom they despise; others like Dylan Thomas gnash their teeth in anger, raging "against the dying of the light"; others like Yeats, construct imaginary paradises with their art:

Consume my heart away; sick with desire
And fastened to a dying animal
It knows not what it is; and gather me
Into the artifice of eternity.

All of them, pessimists and optimists alike, agree that life is essentially meaningless. The poets and the novelists brood like suicidal Hamlets on the great cheat of their existence—Hardy, Conrad, Hemingway, Camus, the list is famous, tedious and long; or they comically deride and satirize, singing canticles of absurdity—Flaubert, Joyce, Nabokov.

Poetry, music and the other arts, including history and philosophy, which we call collectively the "humanities", are the chief instruments of human values. But Humanists in modern times, largely on the pessimistic side, deny there is any end, purpose or value to the universe or human life and therefore put up no positive alternative to its technological transformation. The humanities today are dominated by a philosophy whose meditation on death concludes to the radical insignificance of human life, and they have nothing to offer us but the amelioration of pain through entertainment and technological change. Humanists have simply capitulated to the more vigorous, positive, aggressive and destructive technocrats. Departments of Classics, Literature, Philosophy,

History, Music, Art and the like at universities are increasingly staffed with experts in the technical problems of editing texts, computerizing indexes and constructing linguistical, sociological and psychological hypotheses—all of which, whatever their value, is not human value; it is scientific research in the humanistic field; it is not itself humane.

Technology of course isn't new. Cain was the first technologist; he invented scientific agriculture and war. Technology new or old is pessimism in an optimistic disguise; it proposes in self-contradiction to its essential gloom what appears to be a hopeful enterprise—the transformation of nature to human use. Because of the fact that life means nothing and that everything will eventually come to nothing according to the doctrine of evolutionary doom, we must act, they say, *as if* that were not so for the time being. The technologist constructs an artificial optimism on the inflationary premise that you can buy now and pay later, that you can take and take and take and let your children's children give. Sam was right, they say—premature in his own case—but someday soon, although you can't take it with you, you can at least indefinitely postpone the agony of having to go, because science is about to conquer most of the power of death; we are about

to synthesize something like the Tree of Life and eat its frozen fruit forever, living a millennium at least between the gaping jaws of an evolutionary yawn. With enough research and the manipulation of the masses, scientists can conquer poverty, outerspace, war, disease and even death. In a word, science will establish the Kingdom of This World. Of course, in the long run the process will self-destruct, but for now—not yet, not yet.

It was Protagoras the Sophist who said, "Man is the measure of all things," and Socrates who gave his life as the price of that proposition's refutation. Socrates said in the last hour of his life, awaiting the grim technologist with the hemlock and speaking of the Sophists,

> They do not care what the truth is but are eager only to make their own view seem true. . . . If you do as I ask, you will give little thought to Socrates and much to truth.

Some things, Socrates said, are true, like death and taxes; there is a reality outside ourselves and inside ourselves in the psychological and spiritual order, by which we are measured: outside, it is called nature; inside, human nature, a reality to which we ourselves are not exceptions and by which we are measured; and happiness consists—exactly opposite to what the technologists say—in conform-

ity with nature, not against it or reconstructing it according to our desires. There are simple, ordinary truths that everybody knows from childhood on. Though he might not know a philosophical or scientific explanation of them, or know them exhaustively, might not know the how and why of them, nonetheless the proverbial man-in-the-street knows the *that* of them, the simple fact of them with absolute certainty—for example, everything that lives will die; all things that move, including us, must come from something else and move toward some end outside themselves; and if you take anything from the soil or air or from your father or your father's father, you must either give it back to future generations or deplete the source. Man is not the measure of truths like these. They measure man and make his life significant.

The sophist says there is no truth, man is the measure. In the moral order he says there is no good or evil but thinking makes it so. And in the practical order he says: I'm number one, I will take all I can get. They are technologists of the whole of life, Epicureans who think the purpose of life is pleasure.

Technology—the new or the old; there isn't any difference whatsoever in the philosophical basis; a computer is a complicated abacus—technology

is the inevitable consequence of Epicureanism; it is the dedication of our lives to the pursuit of happiness defined as pleasure; it is the dedication of our lives entirely to ourselves, self-serving, taking everything as means, as if there were no end, no end to things or to ourselves, as if our lives have no ultimate purpose, no goal against which their progress can be measured; and so we spend these lives, as Shakespeare said, in a "waste of shame", endlessly multiplying instruments, turning ourselves and our friends into instruments— we call it behaviorist psychology, Shakespeare called it lust:

> The expense of spirit in a waste of shame
> Is lust in action. . .

Lust in the narrow sense is the use of sex for the purpose of pleasure as if children were preventable accidents which, with proper precautions, need not occur. In the wide sense lust is all human energy, intellectual, emotional, physical, employed for the sake of pleasure, personal and selfish or collective and selfish, as when we define happiness as the greatest good for the greatest number—but still the greatest good as pleasure— pleasure for the greatest number of ourselves, so still for ourselves and nothing more. Capitalism and communism are not so different at the heart be-

cause both enslave us to our instruments, both are selfish, though of course the one is so much worse because it is totalitarian that we must defend the other as the lesser evil. But still the best defense of whatever is left of the "free" world is a radical return to its roots—radical means roots—which are Christian. Capitalism is a secular simony, a selling of what is owed to one another in charity.

Anyone can see that wings are for the sake of flight and not the other way around; the bird is not some cumbersome instrument for the purpose of getting wings to wiggle. The wing is for the bird's locomotion, for fleeing predators, getting food for himself and a mate for offspring. And anyone can see that the pleasure in sex is for the procreation of the human species; no one in his right mind supposes that in the economy of nature children and all the difficult and elaborate consequences of their upbringing are nothing more than a needless excuse for securing genital contentment. Or in eating, anyone can see that taste insures nutrition, not the other way around. Pleasure is nature's way of encouraging us to do necessary things in themselves not always pleasant. Those who live for pleasure, delighted by the attractive package, throw the gift away— in this instance of sex, the great gift of life itself.

Now having grasped this principle in these ob-

vious examples, we must ask, at last, what is the purpose of ourselves? What is the end necessarily outside ourselves, because nothing which moves is already where it is going—if it were it would be there and couldn't move. And so we ask, what is the end of human life? Where are we going? Why?

Well, whatever we profess, our actual behavior clearly indicates that we don't know. As persons in our private lives—such of the private as is left—and as a nation, we are a desperate collectivity of hedonists indulging in fast food, faster sex and any other fastest pleasure we can catch, high-minded or low, ugly or arty, whether you play against one-armed bandits for a hatful of silver slugs, or against elaborate ideologies at universities, or against cancer cells and galaxies at scientific institutes for the Nobel Prize, whether high or low, it is the same seizure of the means of going, as if somehow more and more and faster and further and longer-living are answers to where and why. If you shoot rockets at the speed of light or practice all the variations on the joys of sex, expand your consciousness, eat all the peyote nuts at UCLA—to where is the rocket shot, who is pregnant with this sex, to what is the mind expanded, what does the yaqui say? If we go to the moon or outer space, or with the new consciousness, into inner-space, at the speed of

sound or light or thought—where have we arrived and from what have we departed, if we have taken ourselves along? As St. Augustine said in that marvelous Latin language at once so humanistic, elegant and precise,

> *Quo a me ipso fugerem? quo non me sequerer?*
> Where can I flee from myself? where I myself won't follow?

Shall we go to outer space or inner-space? But we shall bring ourselves along. Columbus found a virgin continent and gave Europe a second chance. Europe got tobacco, cotton and the economic basis for the slave trade because she brought herself along. If we discovered paradise, some real estate operator would subdivide it into building-lots and in a year reproduce Los Angeles. If we fly to the stars, we shall have star-wars, because man bears the mark of Cain, the mark of the Beast. Technology got us into this mess and the more it spins its wheels to get us out, the deeper it digs. It magnifies and spreads whatever we are, and what we are is a generation of Epicureans who live for themselves, for whom life is a tale told by an idiot, signifying nothing; and so we multiply and spread this destructive force of nothing. Our human values and the new technology are all of one compact—they stem like the horns of a di-

lemma from the one head of radical insignificance
—the absolute conviction that there are no ab-
solutes and therefore no convictions.

We are a people of the media; the media can
make and break a president or start and stop a war.
Media signifies "means". What kind of logic is it
when the means are identified as the end, when the
very word signifies the things which are done for
the purpose of achieving an end? If there is no end,
then there can't be any means or media; you are
dealing with a nonentity. And this nonentity at the
heart of capitalism in its rampant stage becomes
the materialist lion of History, which, Marx said,
is determined by the "means of production".

Dialectical materialism is a variety of mechan-
ism. Marx held that the invention of new tools,
changing the modes of production, renders the
prevailing modes of ownership obsolete. The
dynamic principle of historical development is the
class struggle in which an old ruling elite, having
lost its function, is superseded by a new class
whose ascendency results from the technological
change. I remember a moment of fatuous solem-
nity on a doctoral examination in Medieval History
when, the professor having asked the cause of
Feudalism, the candidate replied, *correctly* we were
told, "the invention of the mould board plough".
Well, yes, as an instrumental cause. But men

make instruments to achieve intelligently conceived ends. There has always been, not a class struggle, but a kind of psychomachia in society between the means available and judgments about the ethics and utility of using them. Certainly the invention of the mould board plough made it possible for men to change the way they farmed; but it was invented because they wanted to find ways of making such changes. And it is true that when the means are there it is often tempting to use them even against reason. But we also know that, despite our failings, reason has, if not prevailed, at least survived. When Europe was Christian, there were chivalric codes of war; when they were broken, Christendom was shocked. Even today, when massacres occur, there is at least some consensus that they should not. But if a society takes instruments as ends, it is governed by a kind of nothing, since instruments are nothing if not means to ends, and nothing can be judged as right or wrong; catastrophe becomes commonplace.

Vast international ideologies of world enslavement are constructed on this fiction, that means are ends. Men are slaves of the technological state and children are expendable accidents of erogenous twitches. The two most conspicuous monsters of the new technology are communism and contraception.

Dante says at the start of his great poem:

> In the middle of the journey of our life,
> I came to myself in a dark wood
> When the straight way was lost.

For us today the straight way of the United States, of English-speaking people, of civilization itself, has been lost. People who care for nothing but themselves inevitably lose to those who, capable of sacrifice, will fight for something more than themselves, which is why we went down to the first defeat in our history, turning over to their exterminators millions of people we had promised to protect, a war we lost not on the battlefield but in the media. A people who live for themselves will not die for each other; they become slaves of those who care so much for something greater than themselves that they will die for it, if not each other; and when that something greater is a person, such a death is then the definition of a famous, much abused word: Love is the death of one's self for the person he loves. "Love is strong as death", the Bride says in the Song of Songs.

My father, in an amateur way, had a fine baritone voice, and one of the warmest memories of my childhood is of him singing, "And for Bonnie Annie Laurie I would lay me doun and dee", and "I would die for love of thee, O mavoureen."

And he would put his arm around my mother's shoulders as she sat at the piano with us children. Those fine, old songs, so much disparaged by the technological literary chic which passes for criticism, because they don't add to the Gross National Product or the liberation of sex.

God knows, even a fish will swim a thousand miles and die of love, but an American will live in shame for the price of a television, stereo and an air-conditioned car. In the midst of a world on fire, with the smoke and stench of the slave-camps in our nostrils, we yearn for the cool relief of an indifferent ice, the slowly lengthening glaciers of the Coca-Cola Archipelago, advancing in our freezing, loveless hearts.

Archaeologists rate a culture by the quality of its ordinary pots and bottles, not just its "serious" art but the everyday utensils preserved by the un-prejudiced democracy of its dumping grounds. An ancient utensil is to us a priceless Grecian urn; the greatest artist in the world today can't make a thousandth of an ordinary Greek pot. Even a Victorian chamber pot is a work of art compared to the vulgar kitsch of a Picasso ceramic. No one will even bother to sift us out but dig right down through the sordid strata we have deposited to the richer people here before us who, primitive as they were, at least made beaded necklaces of seashells and jade. A silly slogan like "the me-

economic depressions, we can live in decent if modest homes, as families, without which men are not even chemicals, but random sets.

It is curious how the arrogant notion that we are masters of the universe has led to the practical error that we are slaves of our instruments. It is not true that because we have invented cars that we must drive them, or rockets, that we must go to the moon, or atom bombs, that we must annihilate the world. The great debates are always over something simple; they are fought over obvious facts. We are the masters, not the slaves, of the things we make, as we are the servants and not the masters of our nature. If we measure our lives by our nature, anyone can see the obvious fact that last year was better than this year; and anyone who remembers ten, twenty or fifty years ago will say the same in spades. Anyone who examines the real evidence, not only in art, architecture, music, literature, but in fabrics, glassware, dishes, knives, forks, spoons and shoes and buttons, anyone who examines the daily, ordinary evidence, can infer that life a century ago with all its faults was tournaments of roses in comparison to the mass-murder of our wars, the assassins of our false peace and the inhumanity of human relations. Life a century ago was harsh, sordid, dangerous, dirty, disease-ridden and cruel; there was slavery

dium is the message" tickles our complacency; and pop art, the indecent exposure of our souls, is the expression of our highest aspiration. Means, means, everything is means—machines and plastic pipes and contraceptives. The poet chanted of the Grecian urn, "Thou still unravished bride of quietness. . . ." For us there is neither quiet nor bride; our girls are rendered unravishable by sex education in the elementary schools. If future generations exist and think of us at all, they will say, digging in our ruins, "This was a people who lived unconsummated lives."

And yet there was a time, not long ago and not ideal like some imaginary Arcadia, when our very real grandfathers lived for something other than themselves and life was more honest, much more hard and worth living. Shall we turn back the clock? Perhaps I shall simply excite unreflecting contempt by saying clearly, emphatically, and without irony, regret or Romantic cant, "Of course!" We can and must turn back the clock—to the right time. The only way out of the current crisis in inflation, energy and all the rest is to simplify, as Thoreau said. Willy-nilly, whether as freemen or as slaves, we shall have to return to poverty. The choice is only whether it will be the desperate destitution of the slave state or the healthy frugality of what Chaucer called "glad poverty".

Glad poverte tis an honest thing certayne. . . .

Of course we can turn back the clock, by which
I mean that technology must be regeared to the
proper dimensions of the human good—and not
the other way around where people, we are told,
"will adjust", which means be engineered to fit
whatever schemes technologists devise, where
education is changed to suit the convenience of the
Registrar, industries are organized for the effi-
ciency of their administration and not the product
or the job to be done, where we are served taste-
less meals under conditions beneath the level of
the feeding-trough in fast-food shops because
they can get us in and out faster with a greater
cash return and fewer dirty dishes—in a word,
where human values are subservient to systems.
The question is not whether you can set back the
clock. Of course you can. Clocks are instruments
to tell the time; they don't create it. The question
is what time is it? What is the human good? I
submit the following ancient proposition as tried
and true: There is such a thing as human nature.
And therefore there is an objective and determin-
able human scale and pace. There is, in short,
an optimum environment for the growth of the
human species. Beneath that optimum there is
a condition of destitution into which rampant

industrialism is thrusting three-quarters of
human race, where, desperate for food and shelt
the miserable human animal grovels in the d
before the first tyrant he thinks will feed hir
and there is an opposite extreme condition (
slothful opulence where something lower tha
the animals—like a fallen angel—grovels befor
himself, sliding in his own fat toward a bestiality
unknown to honest pigs and goats. Rising like a
mountain range between these twin abysses of
despair is the golden mean of ordinary life which
we clearly passed a hundred years ago. It is time
to go back to those conditions in which human
beings can grow again, not just to clean air and
water, which some technologists think they can
get by heavier applications of the chemistry that
got them dirty in the first place, but to natural
air and water, to flowers and trees and more
importantly to neighborhoods and villages where
we can walk at a normal human speed, shop in
friendly stores where the butcher and the grocer
know their customers, send our children off to
a school where the parents know the teacher and
the teacher loves his subjects and his students. Of
course, because we are human, we shall fail; but,
because we can converse with one another, there
is the possibility that we can become friends
and, though it will not solve world crises and

dium is the message" tickles our complacency; and pop art, the indecent exposure of our souls, is the expression of our highest aspiration. Means, means, everything is means—machines and plastic pipes and contraceptives. The poet chanted of the Grecian urn, "Thou still unravished bride of quietness. . . ." For us there is neither quiet nor bride; our girls are rendered unravishable by sex education in the elementary schools. If future generations exist and think of us at all, they will say, digging in our ruins, "This was a people who lived unconsummated lives."

And yet there was a time, not long ago and not ideal like some imaginary Arcadia, when our very real grandfathers lived for something other than themselves and life was more honest, much more hard and worth living. Shall we turn back the clock? Perhaps I shall simply excite unreflecting contempt by saying clearly, emphatically, and without irony, regret or Romantic cant, "Of course!" We can and must turn back the clock— to the right time. The only way out of the current crisis in inflation, energy and all the rest is to simplify, as Thoreau said. Willy-nilly, whether as freemen or as slaves, we shall have to return to poverty. The choice is only whether it will be the desperate destitution of the slave state or the healthy frugality of what Chaucer called "glad poverty".

Glad poverte tis an honest thing certayne. . . .

Of course we can turn back the clock, by which I mean that technology must be regeared to the proper dimensions of the human good—and not the other way around where people, we are told, "will adjust", which means be engineered to fit whatever schemes technologists devise, where education is changed to suit the convenience of the Registrar, industries are organized for the efficiency of their administration and not the product or the job to be done, where we are served tasteless meals under conditions beneath the level of the feeding-trough in fast-food shops because they can get us in and out faster with a greater cash return and fewer dirty dishes—in a word, where human values are subservient to systems. The question is not whether you can set back the clock. Of course you can. Clocks are instruments to tell the time; they don't create it. The question is what time is it? What is the human good? I submit the following ancient proposition as tried and true: There is such a thing as human nature. And therefore there is an objective and determinable human scale and pace. There is, in short, an optimum environment for the growth of the human species. Beneath that optimum there is a condition of destitution into which rampant

industrialism is thrusting three-quarters of the
human race, where, desperate for food and shelter,
the miserable human animal grovels in the dirt
before the first tyrant he thinks will feed him;
and there is an opposite extreme condition of
slothful opulence where something lower than
the animals—like a fallen angel—grovels before
himself, sliding in his own fat toward a bestiality
unknown to honest pigs and goats. Rising like a
mountain range between these twin abysses of
despair is the golden mean of ordinary life which
we clearly passed a hundred years ago. It is time
to go back to those conditions in which human
beings can grow again, not just to clean air and
water, which some technologists think they can
get by heavier applications of the chemistry that
got them dirty in the first place, but to natural
air and water, to flowers and trees and more
importantly to neighborhoods and villages where
we can walk at a normal human speed, shop in
friendly stores where the butcher and the grocer
know their customers, send our children off to
a school where the parents know the teacher and
the teacher loves his subjects and his students. Of
course, because we are human, we shall fail; but,
because we can converse with one another, there
is the possibility that we can become friends
and, though it will not solve world crises and

economic depressions, we can live in decent if modest homes, as families, without which men are not even chemicals, but random sets.

It is curious how the arrogant notion that we are masters of the universe has led to the practical error that we are slaves of our instruments. It is not true that because we have invented cars that we must drive them, or rockets, that we must go to the moon, or atom bombs, that we must annihilate the world. The great debates are always over something simple; they are fought over obvious facts. We are the masters, not the slaves, of the things we make, as we are the servants and not the masters of our nature. If we measure our lives by our nature, anyone can see the obvious fact that last year was better than this year; and anyone who remembers ten, twenty or fifty years ago will say the same in spades. Anyone who examines the real evidence, not only in art, architecture, music, literature, but in fabrics, glassware, dishes, knives, forks, spoons and shoes and buttons, anyone who examines the daily, ordinary evidence, can infer that life a century ago with all its faults was tournaments of roses in comparison to the mass-murder of our wars, the assassins of our false peace and the inhumanity of human relations. Life a century ago was harsh, sordid, dangerous, dirty, disease-ridden and cruel; there was slavery

in the American South. But these were early symptoms of the new technology. Even in the cities—witness Dickens' London with all its suffering—*a fortiori* in the villages, life was substantially human, rich, beautiful and free compared to ours in this easy wasteland of wage-slaves, locked in the gaudy ball of ugliness and cheap bad taste.

Take a look at your city, suburb, town, or even factory-in-the-fields still anachronistically called farm. Ask honestly if the place has been improved since its purchase from the Indians or if you have been improved by living there. As children we went to the Gypsy once who turning up our palms to read our fortunes said, "Now this is the hand that God made, and this is the hand that you made." And we cupped the one we made as if to hide it in shame. Does it have to be that way? Our fathers lived for better things than themselves.

You can move back a hundred years by a trip to rural Europe. There are still some villages left where you can see direct, visible proof that the human race can live in harmony with nature on a human scale, decently in "glad poverty", not in destitution but with a snug, hard-working frugality where villages like necklaces and rings still ornament the hills. You can see with your own eyes that there is no inevitability in the suicide of civilization. If America had been governed

by its farmers and craftsmen supplying their real needs and nothing more, as Jefferson hoped, not catering to lust and the agitated sloth which masquerades as lust, without the waterbeds and cyclotrons but obedient to the Christian religion and the rough philosophy of frontier common sense, New York, Chicago and Los Angeles would be as beautiful as Assisi, Chartres and Salamanca and its sons as strong, generous and free as cavaliers, and not the fat cats jamming the freeways in their red Corvettes, puffing joints in the college dorms, drunk on the undistilled bilge they get from the entertainment industry which manages the courses and produces the textbooks from its headquarters at Princeton and Yale. Flee, for God's sake, flee from the sapped ramparts of success. Go home to the ruined neighborhoods and villages of your childhood and rebuild them. They will accuse you of nostalgia. In Greek nostalgia means "homesickness". Our hearts have been pierced like the sad heart of Ruth sick for home amid the alien corn. Contrary to the famous verse, home is something you have very much to deserve. In fact you must sacrifice your life for it. If we all went home, any village in America today could be as beautiful, good, strong and free as Lissoy was in Oliver Goldsmith's youth—he calls it Auburn in his poem:

Sweet Auburn! loveliest village of the plain,
Where health and plenty cheer'd the labouring swain,
Where smiling spring its earliest visit paid,
And parting summer's lingering blooms delayed:
Dear lovely bowers of innocence and ease,
Seats of my youth, when every sport could please,
How often have I paus'd on every charm,
The sheltered cot, the cultivated farm,
The never-failing brook, the busy mill,
The decent church that topp'd the neighboring hill,
The hawthorn bush, with seats beneath the shade,
For talking age and whisp'ring lovers made;
How often have I bless'd the coming day,
When toil, remitting, lent its turn to play,
And all the village train, from labour free,
Led up their sports beneath the spreading tree;
While many a pastime circled in the shade,
The youth contending as the old surveyed;
And many a gambol frolick'd o'er the ground,
And sleights of art and feats of strength went round;
And still as each repeated pleasure tir'd,
Succeeding sports and the mirthful band inspir'd;
The dancing pair that simply sought renown,
By holding out to tire each other down;
The swain mistrustless of his smutted face,
While secret laughter titter'd round the place;
The bashful virgin's side-long looks of love,
The matron's glance that would those looks reprove:
These were thy charms, sweet village; sports like
 these,

With sweet succession taught e'en toil to please;
These round thy bowers their cheerful influence
 shed,
These were thy charms—But all these charms are
 fled.

Why fled? Because even by Goldsmith's day un-
bridled greed, set free from the healthy, cheerful
restraints of Christianity, ran toward ruthless Epi-
cureanism which disguised its radical irrationalism
under the painted rubric of the Age of Reason,
the so-called Enlightenment, in reality a dark
misology which said that reason is the instrument
of man and not of truth, and that we are slaves
to truthless human systems in the application of
reason to the fulfillment of lust in what we call
the Industrial Revolution, first wave of the bloody
tide of revolutions we haven't seen the end of yet.
Goldsmith, living up to his name, like the perfect
craftsman, fixed his righteous indignation in a
couplet:

Ill fares the land, to hast'ning ills a prey,
Where wealth accumulates and men decay.

Measure these famous verses against your own
experience, with your own eyes and nose right
in your own city, not with the deceiving instru-
ments of organized public relations, the economic
growth-charts, probabilities, projections; measure

the plain, immediate, evident reality. Look at the
hand that God made and at the hand that we made.

> Ill fares the land, to hast'ning ills a prey,
> Where wealth accumulates and men decay:
> Princes and lords may flourish or may fade;
> A breath can make them, as a breath has made;
> But a bold peasantry, their country's pride,
> When once destroyed, can never be supplied.
>
> A time there was, 'ere England's griefs began,
> When every rood of ground maintained its man;
> For him light labour spread the wholesome store,
> Just gave what life required, but gave no more;
> His best companions, innocence and health;
> And his best riches, ignorance of wealth.
> But times are alter'd; trade's unfeeling train
> Usurp the land and dispossess the swain;
> Along the lawn, where scatter'd hamlets rose,
> Unwieldly wealth, and cumbrous pomp repose;
> And every want to opulence allied,
> And every pang that folly pays to pride.
> Those gentle hours that plenty bade to bloom,
> Those calm desires that ask'd but little room,
> Those healthful sports that grac'd the peaceful scene,
> Liv'd in each look, and brighten'd all the green;
> These, far departing, seek a kinder shore,
> And rural mirth and manners are no more.

Now there are no "kinder shores", and we must

face what Goldsmith would postpone. "Philosophical happiness", said Edmund Burke, "is to want little"—that is, less of things and therefore more of truth, beauty, mirth, merriment and friendship.

What is all the rest besides? Microphones amplify but, far from improving, distort the voice; Shakespeare wrote all the better for the lack of typewriters; Homer perhaps better yet for the lack of writing at all; electric lights have not improved the content of our reading, nor literacy the quality of our poetry and prose. Take any human activity and measure it against reality instead of the Gross National Product. We have a very gross national product; perhaps we have the grossest national product of any nation in history and not in a single city or town is it good or even safe to bring up children.

But what can we do? Is Karl Marx right, after all? Are we determined by our instruments? Are we helplessly enslaved to a technology anyone can see is killing everything worth living for? Prophecies like those of Marx tend toward self-fulfillment because they paralyze counter-action. What can you do against the inexorable economic laws of history? Well, maybe nothing. Let's concede him history. Who knows about some statistical entity called "history"? But what about the

concrete reality of ourselves? Anyone, right now, can live a better life if he wants to wherever he is —it is not a matter of moving to "kinder shores", or anywhere else "out of this world", except to the unexplored frontiers behind our own closed doors. The answer lies where it always has, not in the laws of nations, which indeed determine the destinies of Sodom and Gomorrah; the answer lies in the laws of the Kingdom within us because there we make the choice. There we are not the slaves of instruments but only of our own bad habits which have demanded the instruments— slaves of our lust for sex, money, power, pleasure and inanition.

Yet each one of us bears within him, like a sleeping giant, the hero of his conscience. Perhaps someone reading these words right now will cross the room and smash the television set. Just that alone, though it will not change some abstraction called history, will make all the difference in his life and especially in the lives of his children. Perhaps someone will smash the television set, turn off the lights, call his family into the living room, start a fire in the fireplace, if there is a fireplace, and if not, why not? Dr. Johnson said you can measure the excellence of literature by the amount of life it contains. Analogously, we can measure the excellence of our houses by how

much of the family they have in them. If you
measure the hi-fi set against a piano, for example,
you can see that families don't gather around
the stereo and sing. Families don't draw their
chairs up closer to the central heating duct. No
one sings while attending to the automatic dish-
washer. But husbands and wives washing and
drying dishes together have actually conversed
and sung; and washing clothes, as we remember
from the *Odyssey*, is a recreation for princesses.
All these labor-saving devices have destroyed
labors of love. The home, the *chaumière*, is the
living building block of civilization, and it consists
materially of walls, a roof and smoke rising from
the chimney. Even the houseless poor, living in
forest huts, sit by the fire, with

> . . . wreaths of smoke
> Sent up, in silence, from among the trees!
> With some uncertain notice, as might seem
> Of vagrant dwellers in the houseless woods,
> Or of some Hermit's cave, where by his fire,
> The Hermit sits alone.

Build a fireplace according to the specifications
of Count Rumford, or his mechanical rival Ben
Franklin, and forget efficiency. As Thoreau said,
we are fools to box up one of the most beautiful
sights in the world—a living fire—and keep it in

the cellar. Smash the television set, turn out the lights, build a fire in the fireplace, move the family into the living room, put a pot on to boil some tea and toddy and have an experiment in merriment, a sudden, unexpected hearth, the heart and first step in the restoration of a home—to hell with history; it's bunk—and see how love will quicken in a single winter's night!

Philosophical realists have never advocated sweeping social change; nothing serious or deep is accomplished by techniques. You cannot improve education by a new curriculum—you need good teachers—or marriage by a change of position. For a sudden, significant reversal in schools and marriage and everything else, you need common sense, tradition, luck and love. Hippies, despite the sentimental exaggeration, have got at half these truths, denouncing quite rightly the sick society they, alas, keep living off as scavangers, on checks from worried parents and food stamps from welfare; they have created a parody of the liberty they yearn for in the simple life, close to each other and the earth. I don't expect or advocate any "final solution" to the world's catastrophe but only a change in the direction of one person. Simplicity is not the product of study; it cannot be prepared for, nor plotted like an assassination; and it is disgusting to see it exploited

by the "whole earth" people and the communists who use it as bait. Alas it is true, as Belloc said, that you can change a farmer's son into a college student in a single semester, whereas it will take three generations to change a college student into a farmer. Long-range change is slow and for practical purposes impossible; but the decision to change oneself is unpremeditated and instantaneous, a systole of the heart. And even if a fraction of the next generation should live in that trembling hope, then when the great change comes, as it always does, like a thief in the night, by surprise, it will come because of them, far from the madding crowd, far from the protests, bull horns, klieg lights and cameras, in that quiet place at home by the fire which in the meantime, little as it is, is of immediate and lasting worth.

Simplify, as Thoreau said, not by changing governments—a change of collars on a dirty neck; not denouncing IBM, Communism, the Catholic hierarchy, the Rosicrucians and Jews; but in a single, honest, unremembered act, as Wordsworth said, of kindness and of love. As the first significant act in the change of heart, really—not just symbolically—smash the television set, then sit down by the fire with the family and perhaps some friends and just converse; talk alone, even one night a week, will cut your use of energy,

and love will grow. Don't force its growth. The hearth, like good soil, does its work invisibly, in secret, and slowly. After a long time beneath the earth of a quiet family life, green shoots of vigorous poverty appear; you have become, in a small way, poor. If several families, sharing this humble secret, buy old houses on the same slum block and fix them up, they will have restored a kind of Auburn right in the midst of their ruined city and begun the restoration of that ordinary, healthy, human thing, the neighborhood. Children, away from the television set, will begin to play outdoors again; several families can support a private, local school where children can learn to read and write again instead of how to cope with mass transit systems and avoid venereal disease. John Dewey taught that schools are instruments of social change rather than of education, and that is one reason why Johnny neither reads nor writes nor dreams nor thinks; but real schools are places precisely of un-change, of the permanent things. And if there is a neighborhood, the corner store will come back again, the barbershop and the convivial bar where men can drink, as Belloc said, because they are happy, not as alcoholics in order to get happy; and more important still the tea-room will reopen where women can forget about dieting for fashion, enjoy life more (a little extra

weight among friends is an honest thing), eat cakes, drink coffee or tea, sip and gossip about the transient things, which are even more important than the permanent ones, all the things that men don't know about and if they did would fail to understand and foolishly disparage—like romance, courtship, childbirth, fidelity, infidelity and death. Woman's place is in the home not because some chauvinist put her there but because there is a law of gravity in human nature as there is in physics by which we seek our happiness at the center.

In the 1970s they used to flash a question in print across the bottom of the television screen around ten o'clock each night: "Where are your children? Where are your children?" It was a good idea to scare the parents because the children were certainly not home in bed, though they may have been in bed somewhere else, at the teenage Bunny Club sponsored by the PTA, sundry churches, Planned Parenthood and the YMCA where they participated in experimental "inter-relationships", "sharing their concerns" and "exploring" each other's bodies and souls. By 1984 things are worse because parents are at the Bunny Clubs and they will have to flash the question to the kids: "Where are your parents?"

My parents died in their own beds at home and are buried a few miles from their birthplace. I

don't expect the same for myself. The old-folks' homes are just down all our streets now, and Big Brother, or Big Sister, will put us there if we but blench, into those sordid tenements, reeking of urine and social work—oh, some are ersatz mansions with aristocratic and even Christian names—but all of them are transient hotels, hospices for the dying as they call them in socialist England, where euthanasia is the buzz word for "final solution" to the problem of old age. In the United States they have been syndicated like fast-food chains, for profit, and in some places vast conglomerations have been constructed, like Sun City and the Everglades.

> Way down upon the Swanee river, far, far away;
> There's where my heart is turning ever;
> *There's where the old folks stay*.

Indeed they do, though not for long. If death is insignificant, when life becomes a pain, why not inject the terminal hypodermic or discreetly indicate the pill? The new technology? The air-conditioned holocaust!

But if instead you cut out all excess technology, and keep grandma around, living in a less pretentious but more livable house and if—I save the best wine for last!—you sell the car and learn to walk again, think of the money you'd save and

all the time now spent on exercise and jogging. And women wouldn't have to work to make the installments and insurance. It really does seem silly to have to say so; you would think we all would know; but half the wages of working wives go on increased taxes and the cost of getting them to work—the second car, the frozen foods and nursery schools, those sweet little drive-in orphanages, worse than old-folks' homes. If women stayed home where they belong, someone would know where the children are and where the old folks are; food would taste like meat and vegetables again because it would be cooked, not just defrosted; life would be wholesome, good and full of love again because she would be home; pianos would shake old music from the scores, children, parents and grandparents would sing together of an evening and tell stories by the fire. Someone would even be home to love and care for the crippled, sick and dying. Women must be liberated from their modern "emancipation", which is really slavish compliance to a Calvinistic and masculine ideal, so they can return to their proper work—greater than medicine, engineering, business and politics—participating with God in the creation and nurture of human life, which cannot be done by even men or angels. Men, of course, procreate and must govern and provide, but—

God save the obvious—only women can conceive and nurse; and in their physical, psychological and spiritual mode they do so long after the weaning of their children.

Who is rich or poor? There is a spiritual destitution, a sterilized third world here in the United States worse than anywhere in Asia or Africa, where the sick and aged die in no one's arms, children are prevented and, if some break through the chemical and physical barriers, aborted; and if by accident or parsimonious planning one or two get by, they are sent to the Lilliputian gulags where they suffer a systematic, scientific child abuse according to the latest issue of *Psychology Today* and are trained to survive in a world without home or hearth, without the warmth of a mother's, and therefore of anyone's, love.

When his followers asked him for a sign, Christ said: "I shall give no sign save the sign of Jonas." Jonas had preached to the wicked city centuries before, prophesying that "In forty days Nineveh shall be destroyed." And Christ said to the people of his day in Jerusalem, and I think to us in our cities as well:

> The men of Nineveh shall rise up in the day of judgment with this generation and condemn it, because they repented.

I haven't used arguments from religious authority because it isn't acknowledged by some whom I shouldn't want to exclude from seriously considering the case, which can be made from natural reason alone. To the majority of Christians, however, it is scarcely necessary to say that if there is a God of justice and love he will not permit such inhumanity as ours for long—though God needn't bother to destroy our city: the *women* of Nineveh shall rise on the Day of Judgment with this generation. An economy which feeds on the technological extermination of over a million-and-a-half unborn children every year destroys itself.

The Catholic Agenda

What will it be like for us when we say the Hail Mary for the last time, when "now" *is* the "hour of our death" and we must say, "Amen"—which means, as we know, "So be it"?

There are many famous "last words" like Sam's "In that case I won't go", or those of the German poet who said, "More light!" which was both Romantic and edifying until a servant disclosed that the great man had just ordered a cup of Viennese coffee and wanted more cream in it —"*Mehr Licht*"—"more light", as the Viennese coffee drinkers say. Or there are the dying words of saints: St. Thomas Aquinas, quoting from the Song of Songs, "Let us go into the fields", or the Blessed Virgin who (all the saints say) died of nothing else than love and so far as we know said nothing. Or St. Catherine of Siena suddenly raising herself from her final coma to cry out, "Blood! Blood!"

In the imminence of death, there is nothing to be done. Death has no agenda. Everything then is consequence, the result of what has been ac-

complished of the items on the agenda of our lives. "Agenda", from the Latin *agere*, "to act" or "to do", is another way of saying, "What is to be done?" "What must be done." Whenever you consider the placing of an action, you are in the order of purpose, that is, you are proposing the end of the operation you are about to perform; and whenever you are in the order of purpose, not one, but three simultaneous but distinct meanings of the term are brought into play: the *immediate*, the *proximate* and the *final*. They are brought into to play together in harmony like three notes of a musical chord all sounding at once.

The immediate purpose is simply to do the job to be done—for the butcher to cut the meat, for the baker to bake the bread, for the teacher to teach the multiplication tables. The proximate purpose is from the Latin *proximus*, meaning "neighbor", exactly as in the phrase, love thy neighbor—*diliges proximum tuum*. The proximate end, perhaps surprisingly, is chiefly accomplished in prayer. And the final, or ultimate, purpose, the reason why we work and pray, is to know and love God as he is in himself, so far as that is possible, in imitating his earthly life in Christ, the chief act of which was sacrifice. The immediate, proximate and final purposes of all our operations can be summed up in three words: work, prayer,

sacrifice. These are the items on the Catholic Agenda. And every time we pray the Hail Mary, we refer to them in the closing phrase: "Pray for us sinners *now*", which is the immediate work to be done, "and at the hour of our death", which is the proximate prayer to be said, because prayer is always a kind of dying, dying to selfishness; and last we say, "Amen", which is sacrifice.

Immediate purposes depend on particular knowledge—butchering, baking and the rest. We can say generally, of course, that God commands us to do a good job at good work. All the prayer and sacrifice in the world is a mockery and blasphemy we drink to our destruction if we are poor workmen; if we don't pull our oar. But how we do that depends on particular knowledge of the trade which each of us is bound to know. But one of the bitterest questions the majority of us must ask is whether, even if we do a good job, the work is good to begin with, that is, if it is really necessary to the common good. A large amount of work in the bureaucratic state consists in what is called management but is really manipulation of labor, supplies and markets; some is gambling on the ups and downs of markets, and some, taking interest on loans. Managers take pride in facilitating and expediting, but how many useless products and needless services are multiplied just for the sake

of being facilitated and expedited? And a lot of management, and labor as well, turns out to be hanging around because of union contracts and tenure.

We must honestly ask of every job, *cui bono*? for whose good? Is this work necessary? Must it be done? Is it really on the agenda of the common good or have we attached a useless rider for our own benefit? The question here is not the reform of the social and economic system, however important that may be, but the particular moral choice each of us must make in the meantime. The whole of our semisocialist society is a vast, lopsided dis-economy in which few do necessary work and many are parasitic. It would be rash to fix any definite degree of sin on the part of those involved in parasitic work, but from the point of view of economic health, we are suffering a plague. Economic life has become an occasion of sin in which virtue becomes morally impossible for the majority. Thoreau said in the often quoted phrase, "Most men live lives of quiet desperation." Their children have not been so quiet.

A test of your own good work would be to think what you will say some day to your grandchildren when they ask, "What did you do in your day, Grandpa?" Burke said that though it is true there is a dignity in work, not all work is dignified —hairdressing, for example.

Supposing that immediate ends are met in good work well done, the proximate end comes into play. The proximate end of work is love of neighbor; work must make us friends. If we are merchants, our job is to make sales honestly, but it is also at the same time to make buyers and sellers friends. Of course we can't do that if the product is a fraud or if we bought it cheap to sell it dear. Friends are not for use; love cannot be theft; it supposes willing the good of the other; it is not a sentimental sauce to make selfishness palatable. Love is not something less than honest work; it is something more.

Everyone is always saying love, love, love. Exhortation gives us guilty feelings but doesn't teach us what it is or how to do it. The saints, who know what they are talking about from experience, all teach what seems at first a shocking doctrine. Though it is repeated often enough in preaching, it seems so out of phase with everything else we do, we treat the familiar phrases rather like esoteric ritual, pious babble appealing to the feelings while intelligence sleeps. But the saints all say that Christian love, or charity, is a force which presupposes and makes use of affection as an instrument but is itself something else: Charity is not a human but a divine work accomplished through human work, with us as its voluntary instruments.

Unless the Lord build the house, they labor in vain
that build it.

There is a serious confusion about immediate
and proximate ends. You often hear it said that
work *is* prayer; that is not what St. Benedict said.
He said work *and* pray.

For our work to be efficacious in the order of
love, we must first dispose ourselves to grace. St.
Catherine of Siena explains this in her *Dialogues*,
in words taken down by secretaries as she dictated
in a state of ecstasy—the "I" is God speaking
through her lips:

> I wish to show thee how a man becomes a friend. . . .
> Every perfection and every virtue proceeds from
> charity, and charity is nourished by humility, which
> results from the knowledge and holy hatred of self.
> To arrive thereat, a man must persevere, and remain
> in the cellar of self-knowledge in which he will
> learn My mercy, in the Blood of My only begotten
> Son, drawing to himself, with this love, My divine
> charity, exercising himself in the extirpation of
> his perverse self-will, both spiritual and temporal,
> hiding himself in his own house, as Peter did, who,
> after the sin of denying My Son, began to weep. . . .
> Peter and the others concealed themselves in the
> house awaiting the coming of the Holy Spirit which
> My Truth had promised them. They remained barred
> in from fear, because the soul always fears until she

arrives at true love. But when they had persevered in fasting and in humble and continual prayer until they had reached the abundance of the Holy Spirit, they lost their fear and followed and preached Christ crucified.

The chief impediment to love of neighbor is love of self. And so the practice of the proximate end of every work is achieved in what St. Catherine calls "the cellar of self-knowledge", where, in tears and penance, like St. Peter's, we find out what we are really like, as St. Peter did, and are ashamed; we bar the door in fear, in the house of Our Blessed Mother, like Peter and the Apostles, and wait for the Holy Spirit of help. Then according to his promise that help comes, and we will be effective in achieving the proximate purpose of our work.

Prayer in the cellar of self-knowledge is actually a social act. Social action in itself is not love of neighbor unless it is a consequence of the love of God. Justice in the world's eyes is a decent wage for work well done, or (to the socialist who has sunk below the level of the world by trafficking in idols) a guaranteed income—something for nothing. Christ's justice lives by Faith; it presupposes work well done, and grace—God's work well done.

Friendship isn't friendliness. Shakespeare says of friendly people that they wear their hearts upon their sleeves. The man who says, "Shake hands; just call me Jack", the first time you meet is probably trying to sell you something you neither want nor need and at an unfair price.

Nothing has been more ruinous of real social action and friendship than the devastation of the contemplative orders accomplished in those names. To hunger and thirst for justice means literally to fast—literally to hunger and thirst. Until we have crushed self-interest and become instruments of the only real agent of charity, every good work is vain.

> If I should distribute all my goods to feed the poor, and if I should deliver my body to be burned, and have not charity, it profiteth me nothing.

This is not an argument for Quietism; there is immediate work to be done. But it is an argument against Liberation Theology. There is no opposition between prayer and work; they are two simultaneous notes on the triple chord of every human act.

Bar the door, St. Catherine says, because real friendship is what spiritual writers call the Devout Life, the Benedictine *habitare secum*, a living alone with yourself. It is the opposite of the affable

smiler, who, as Chaucer says, often has "the knyf under the cloke". Friendship is the loss of profit in one's self by which the prayerful butcher cuts the meat, perhaps without a word, but cuts it dutifully and well and loves his customer as himself, knowing himself. Of husband and wife, St. Thomas said they should be friends—a remarkable remark; like so many of the saints', so simple you can miss its import. The immediate purpose of marriage is the procreation and nurture of children; but the proximate purpose is that children are occasions of prayer.

And at last, supposing good work well done and prayer, the final purpose of human action, the third note of the chord, comes into play. Insofar as God works in us, he lives in us. The saints all say that every human act, performed in grace, is a participation in the intimate, infinite life and love of the Blessed Trinity; it is sacramental, mysterious. And in this life, that life can only be understood, like the pattern from the underside of an Oriental rug, not as joy but suffering, as Christ's action on the Cross, as sacrifice. Every work and every prayer on earth is a participation in the joys of Heaven by means of suffering. It is a paradox that every Christian act is a passion. *In hoc signo vinces*—the sign of the Cross.

When we say the Hail Mary, we refer to the

immediate purpose of work by the word "now"; "pray for us sinners now" because now is the hour of our work in the sweat of our brows—that is the life of man on earth. We refer to the proximate purpose in the Hail Mary when we say "at the hour of our death", because prayer is a kind of dying. As Socrates said in *The Republic*, all philosophy is a meditation on death. Revelation repeats the philosophic truth: Man, know that thou art dust and to dust thou shalt return. St. Catherine said, "Go into the cellar of self-knowledge and learn the death of self." And the final purpose is expressed in the Hail Mary when we say "Amen". Sacrifice is the offering of the purified self to the greater glory of God. This is the Catholic Agenda —work, prayer, sacrifice, "now and at the hour of our death. Amen."

When the Sons of Thunder wished to follow Jesus in his glory, he said to them: "You know not what you ask. Can you drink of the chalice that I drink of?" And they said: "We can." James was the first of the Apostles to be martyred, hurled from the roof of the Temple at Jerusalem, while John, the last, lived out a very long life in exile waiting for that drink. To follow Christ all the way as a religious, or halfway, making up the whole with a husband or wife in marriage, is to participate in the great Sacrament reenacted at Mass. Sacrament means sacrifice: it is a partici-

pation in the work of the Cross. We work at jobs to be successful and though it seems obscure at first, if we try we can learn to become men of prayer and see more clearly the human signifi- cance of our jobs. But what is the relation of work to sacrifice?

St. Thomas More, who as Chancellor of Eng- land was one of the wealthiest and most success- ful men of his time, all through a remarkable public career, wore beneath the expensive clothes his offices demanded a very private hair shirt about which no one ever knew except his devoted daughter, Margaret, to whom he confided the distasteful task of washing out the clotted blood and bits of torn skin. And we know how at the end he said "Amen" with a jest, cheerfully offer- ing his neck for the right of Catholics to assist at the Holy Sacrifice of the Mass in England.

In more ordinary terms, Cardinal Newman posed the question this way: What would you have lost if the Catholic Faith were false—which it isn't, but supposing it were? How much of your life would have been spent in vain? How much have you invested in the Faith? Or have you made such a good deal with the world meanwhile that it wouldn't hurt you much? In your business, in your marriage, in your school, in your Church— how much have you had to give up for the Faith?

Work, prayer, sacrifice—what God hath joined,

let no man put asunder. Whenever these are split, you have a turning away and a heresy, not just a weakness or ordinary sin, but an implicit denial of the Trinity: The Son is work, the Holy Ghost is prayer—Who prays in us with unspeakable groanings—and it is to God the Father that Christ offered his Body and Blood in the Sacrifice of the Cross and continues to do so on the altar.

Immediate purposes depend on particular knowledge of particular trades, but there are some generalizations the Church has made about them, especially in the series of Social Encyclicals which teach essentially that wherever an effective number of a nation is Catholic (it needn't be anything like a majority, but just enough as a unified and determinant minority to shape policy) the political and social power of the faithful must be used in favor of what economists call a distributist rather than a capitalist or socialist society, that is, one in which the tax and other public instruments work to favor independent, small, free enterprise and especially the family farm. If that seems remote and anachronistic in this age of international conglomerates, condominiums and communist supremacy, remember the Fall of Babylon and Rome, the impotence of Egypt and the strength of Medieval Christendom against overwhelming

odds in the Crusades. The one certain thing about the future is that it is full of surprises. One hundred years of Marxist prophecy has failed; fifty years of intensive communist industry and agriculture in Russia have failed; thirty years of half-hearted British socialism is sagging badly. Capitalist triumphalism in America is at least badly embarrassed by inflation, urban destitution, incipient bilingualism and crime. The chairman of one of the largest state-controlled corporations in the world wrote a best-seller just before his recent death in which he advocated not just the obvious desirability from the human point of view, but even the economic necessity, of returning to Catholic social principles to save the dying economy of socialist England. E. F. Schumacher's *Small Is Beautiful* is chiefly remarkable for its hardheaded realism; the author is not an academic dreamer but a very successful business man; it is a stunning witness to the timeliness, urgency and practicality of the Catholic Agenda in the order of immediate ends.

Catholics are not cranky, fanatical, romantic, idle, farfetched and quixotic; it is the Lord Who commands. This is not only a question of the workingman's religion, but the religion of his work; the work itself must be in harmony with God's plan, which is nature's plan too because

God is the author of nature. We shall never find economic, domestic or political and social security *contra naturam*, in a society contraceptive of children and of everything natural and real.

Prayer is even more important. According to the great verses of St. Paul, all the economic health in the world is death unless its motive is charity; as St. Catherine said, charity begins in prayer—and the first thing we say about prayer is that we don't have time for it!

By prayer I mean above all the practice of solitude and silence exemplified perfectly by the Blessed Virgin who did little and said less because the best communion with her Son was secret, private and quiet. When Christ was born, the pagan oracles were struck dumb, the devils fled from their sanctuaries and a voice cried out of the sky, "The great god Pan is dead!" A frightening sign of our times has been the profanation of contemplative convents, the systematic destruction of the life of consecrated virginity and silence, the vulgarization of the Divine Office—nuns crying in the street that Christ is dead.

Work is a physical necessity; if you don't work you don't eat. Prayer is a necessity of obligation; if you don't pray you will not enter the Kingdom. Prayer is a duty, an office; it is a free, voluntary payment of the debt we owe to God for existence

and grace. The Latin word for duty is *officium*, and the perfect prayer of the Church is its Divine Office; St. Benedict called it the *opus Dei*, the work of God.

I have cited the Latin for the meaning of many words not for the pretense of learning but because their meaning is Latin. Latin is the language of the Roman Catholic Church; you can repudiate the tradition and overthrow the Church; but you cannot have the tradition and the Church without its language. And though the Second Vatican Council *permitted* the substitution of vernacular liturgies where pastoral reasons suggested their usefulness, it *commanded* that the Latin be preserved. The Catholic Faith is so intimately bound to the two thousand years of Latin prayers any attempt to live the Catholic life without them will result in its attrition and ultimate apostasy—which we have witnessed even in the few years of the vernacular experiment.

We must return to the Faith of our fathers by way of the prayer of our fathers. The chief duty of priests is the daily recitation of the Office which they certainly have a right to recite in Latin; Latin breviaries of the new rites exist; and for religious, most of the monasteries and Orders have outstanding privileges so that the entire tradition can be maintained in its integrity and secular priests

can enjoy these privileges by the simple and meri-
torious expedient of becoming oblates or joining
third orders. For the laity, participation in at least
some of the canonical hours recited publicly in
churches and oratories is strongly advised and
where it is not available it should be respectfully
petitioned; and of course lay participation in the
approved devotions of the Church, the Little
Office of the Blessed Virgin, Benediction, the
Angelus, Stations of the Cross, Forty Hours and
the Rosary is an obligation of charity in an age
when prayer for all practical purposes has ceased,
like the pagan oracles at the birth of Christ—and
now those gods return,

> . . . a vast image out of *Spiritus Mundi*
> Troubles my sight: somewhere in sands of the desert
> A shape with lion body and the head of a man,
> A gaze blank and pitiless as the sun,
> Is moving its slow thighs, while all about it
> Reel shadows of the indignant desert birds.

In Millet's famous painting of the Angelus, the
tired ploughman after a good day's work, stands
with his head bent at dusk, cap in hand, his wife
at his side, listening to the tolling of the bell,
participating at his weary work in the fields in that
other greater work of gratitude the priest sends up
to God from the distant church. The perimeters

of parishes were once determined by the distance
steeple bells could sound. The "cockney" strictly
speaking is anyone living within the sound of the
bell of St. Mary le Beau, one of the churches
enumerated in the nursery rhyme:

> Oranges and lemons,
> Say the bells of St. Clemens

including the verses

> You owe me five shillin's,
> Say the bells of St. Helen's.
>
> When will you pay me?
> Say the bells of Old Bailey.
>
> When I grow rich,
> Say the bells of Shoreditch.
>
> When will that be?
> Say the bells of Stepney.
>
> I do not know,
> Says the great bell of Bow.

In some churches they still ring the steeple bells
at the Elevation so those at work or suffering in
hospitals can make a spiritual communion. Bells
are a benediction sounding out in circles all the
way to the everlasting hills.

Of course the simplest, most practical restora-
tion of Christian Culture will be the reestablish-
ment of contemplative convents and monasteries.
Without publicity or the raising of large amounts

of money, because grace is not visible or audible in itself and is very poor, just one small house of a few virgins consecrated to the total life of prayer will reinvigorate the spiritual life of a dying town.

For the rest of us, laymen and priests in the active life, we must put this on our agenda: Encourage young men and women—particularly women, who have the greater aptitude—to do as Our Lord said, "Be perfect." Of all the possible careers the young might consider and choose, they must put God's choice first and consider the possibility of a call to the contemplative life. That again is not a choice but an obligation. And this means that books must be made available describing and explaining the life, visits and retreats must be arranged if houses of contemplative prayer with the Latin liturgy can be found. Parents, priests and teachers who fail at this have committed sins of spiritual contraception against the next generation. For priests and religious who abandon or disgrace this life, it were better far if a millstone were tied about their necks and they were cast into the sea.

Even those of us in the active life are called to a tithe of the contemplative as well. The strictly cloistered monk and nun lead that life in the highest degree, but each of us in his station must pay his due. There are three degrees of prayer: The first,

of the consecrated religious, is total. They pray always, according to the counsel of Our Lord. Their whole life is the Divine Office, Mass, spiritual reading, mental prayer, devotions and the minimum work necessary to maintain physical health. They pray eight hours, sleep eight hours and divide the other eight between physical work and recreation. The second degree is the mixed life in the active orders and secular priesthood, which is still primarily devoted to prayer. These pray four hours, sleep eight, work eight—preaching, teaching, caring for the sick and poor—and have four hours for recreation. The third degree is for those in the married state (or single life) who offer a tithe of their time for prayer—about two and one-half hours per day—with eight hours for work, eight for sleep and the remaining five and a half for recreation with the family.

Everyone will say at once, it can't be done. That is what I meant when I said that the first thing said about prayer is that we don't have time for it. But the reason why we don't is that priests don't lead the way by praying their four hours every day, and monks and nuns don't lead them by keeping all the vigils of the night. We are suffering from the domino effect. Every layman owes his tithe of time—two and one-half hours per day!

The first question on the agenda of prayer is

time: Where has time gone? Well, for one thing it has gone into useless work and in the cities into the tangled difficulties of getting to work and then into the consequent increased necessity of getting away from work in complicated, expensive, time-consuming, unproductive and destructive ways of recreation. In the order of work, I really do recommend reading *Small Is Beautiful* and if you have access to a good bookstore or library, the works of those great crusaders of the last generation: Hilaire Belloc, whose pamphlet *The Restoration of Property* is the best Catholic economic and social manifesto in English, and his friend G. K. Chesterton, who wrote widely and well with wit and good humor about decentralization and the restoration of the social order. In the order of recreation, which is a subdivision of work since it means rest from work, if you would dig up your front and back yard by hand and plant them full of flowers and vegetables, you would replenish the table, beautify your lives, lose weight, and gain physical and emotional strength and cheer sufficient to cancel the trip to the mountains and quit the absurd and unhealthy exhibitionism of jogging. And unless we restore order in work and recreation of course there will never be time for prayer.

If, as I suggested in the last chapter, we find ways to restore neighborhoods where we could

shop and even work, where the children could walk to school and women could stay home, then time would stretch, become more flexible, our nerves would be less tight, the pressure would be less. We are in a downward, reciprocally causative spin: because our work is disordered, there is no time to pray, and because there is no time to pray our work grows worse. Prayer is the proximate end of every immediate work; it is the humble soil, the humus of our common humanity, irrigated by tears of contrition. Works without prayer are dead. Prayer and work are not the same thing —you cannot use the one as a substitute for the other, in the heresy of good works on the one hand or the Quietism on the other. Work needs prayer as dry cracked leather needs oil; prayer fills the pores of work and makes it flexible, useful to God.

Anyone caught up in the bad work of real estate development or architecture and building must consider how diligently the atheist has worked, how imaginatively he has constructed housing projects and public buildings to foster his religion; whereas Christians have behind them the best and loveliest housing developments in history in the Catholic villages of Europe, and fail to reproduce them. We visit them, take pictures of them, never dreaming we could live in them, when as a matter

of fact it is feasible if not profitable to construct something like them even in the suburbs of New York or San Francisco, advertising them as Christian Heights or Flats! After all isn't that what names like Los Angeles and San Francisco once signified? I submit for serious consideration, even for those living in suburbs and cities, the reestablishment at least of what were once called Catholic ghettos. For young and more adventurous souls, there is the vast, still-virgin wilderness to the north waiting for saints. Of course there are difficulties in some ways worse than wild savages once were, I mean the bureaucratic state which, threatened by the slightest exercise of real religious freedom, will descend with building permits, certification of schools, and taxes. The Amish, Dunkards and other sects have fought these things better than we have and have lived their poor religions better than we have lived our truly poorest one.

But supposing we have managed to arrange our physical lives to the point of tithing time for prayer—how do we do that? Is there a how-to-do-it-book? And of course there are many. St. Philip Neri, when someone asked him for a reading list, replied, "Read anything by anyone with the word Saint in front of his name!" Pick any saint you want; they all say the same things in almost the same words, and this is what they say:

First, prayer is quiet. Anything loud, rambunctious, shouting and stomping, certainly anything with electric guitars and microphones, is unmistakably *not* prayer. The old lady in the darkened church who prays and prays, who doesn't know our name and never asks and seldom smiles but often weeps before a candle lit to Our Blessed Mother and St. Joseph and their friends the other saints—she knows how to pray. She has come to herself long since in the cellar of self-knowledge and she has come to a knowledge of us as well. She knows us, though she may never know our names; and she prays for us. Men come closer together in quiet prayer than in any other way— come closer to each other because closer to Our Father in Heaven, because the Kingdom of Heaven is within the soul of each of us and insofar as we approach that Heaven inside ourselves we are just as much inside the souls of each other. The hermit in his cell, lost in the fastness of the desert says his private Mass more efficaciously than priests and bishops and the pope himself in the great basilicas —because more concentrated on God alone. Mary was closer and a better friend to the whole human race than all the activists in history together when alone in her little room she said *Fiat mihi secundum Verbum Tuum*. How many assisted at the Crucifixion? Only four are cited, three named Mary. As

the prophet Elias found, God is not in the thunder but in the whistling of the gentle air.

Here's one with Saint in front of her name to testify: "Do not be dismayed, daughters, at the number of things which you have to consider before setting out on this Divine Journey, which is the Royal Road to heaven." St. Teresa wrote in Spanish and the words she uses here are the famous *Camino Real*—the Royal Road, which is prayer. "If anyone tells you it is dangerous, look upon that person himself as your principal danger and flee from his company." Note well what she says: Anyone who tells you that prayer is obsolete; that it is better to spend your time on social action, is not just wrong, but your principal danger. And having said as much, St. Teresa proceeds to teach us how to pray, exactly as Our Lord Himself did, by means of the Our Father. If we learn how to pray this prayer we will have the secret of all prayer and be at the end of the *Camino Real* in the presence of God. This is what she says:

> Our Father Who art in Heaven. Do you suppose it matters little what Heaven is and where you must seek your most Holy Father? I assure you that for minds which wander it is of great importance not only to have a right belief about this but to try to learn it by experience, for it is one of the best ways of concentrating the mind and effecting recollection

of the soul. . . . Do you suppose it is of little impor-
tance that the soul which is often distracted should
come to understand this truth and to find that, in
order to speak to its Eternal Father and to take its
delight in Him, it has no need to go to Heaven or to
speak in a loud voice? However quietly we speak,
He is so near that He will hear us: we need no wings
to go in search of Him but have only to find a place
where we can be alone and look upon Him present
within us. . . . Remember how important it is for
you to have understood this truth—that the Lord
is within us and that we should be there with Him.
If one prays in this way, the prayer may be only
vocal, but the mind will be recollected. . . . It is
called recollected because the soul collects together
all the faculties and enters within itself to be with its
God. . . . It withdraws the senses from all outward
things and spurns them so completely, that without
its understanding how, its eyes close and it cannot
see them and the soul's spiritual sight becomes clear.
Those who walk along this path almost invariably
close their eyes when they say their prayers. . . .
Perhaps you will laugh at me and say that this is
obvious enough; and you will be right, though it
was some time before I came to see it. I knew
perfectly well that I had a soul, but I did not under-
stand what that soul merited, or Who dwelt within
it, until I closed my eyes to the vanities of this world
in order to see it. I think, if I had understood then, as
I do now, how this great King really dwells within

this little palace of my soul, I should not have left Him alone so often, but should have stayed with Him and never allowed His dwelling-place to get so dirty. How wonderful it is that He Whose greatness could fill a thousand worlds, and very many more, should confine Himself within so small a space, just as He was pleased to dwell within the womb of His most holy Mother!

I am not asking you now to think of Him, or to form numerous conceptions of Him, or to make long and subtle meditations with your understanding. I am asking you only to look at Him. For who can prevent you from turning the eyes of your soul (just for a moment, if you can do no more) upon this Lord? You are capable of looking at very ugly and loathsome things: can you not, then, look at the most beautiful thing imaginable? Your Spouse never takes His eyes off you, daughters. He has borne with thousands of foul and abominable sins which you have committed against Him, yet even they have not been enough to make Him cease looking upon you. Is it such a great matter, then, for you to avert the eyes of your soul from outward things and sometimes to look at Him? See, He is only waiting for us to look at Him, as He says to the Bride in the Song of Songs. . . . Behold He standeth behind our wall, looking through the lattices.

If you are suffering trials, or are sad, look upon Him on His way to the Garden, or bound to the Column, full of pain, His flesh torn to pieces by some, spat upon by others, denied by His friends,

and even deserted by them, with none to take His part, frozen with the cold, and left so completely alone that you may well comfort each other! Or look upon Him bending under the weight of the Cross and not even allowed to take breath! He will look upon you with His lovely and compassionate eyes, full of tears, and in comforting your grief, will forget His own because you are bearing Him company in order to comfort Him, and turning your head to look upon Him.

Laugh at St. Teresa in her simplicity if you dare. Stupid old woman—and Doctor of the Universal Catholic Church. St. Teresa, pray for us, so we may learn to pray the way you tell us to! At Mass, Rosary, Lauds, Vespers and at private prayer, all our prayers should approach to what she says—to bear him company on the *Camino Real*, the Royal and *real* Way of Christ the King on the Way of the Cross.

There are those who say one should reserve, in prudence, certain difficult things and hard sayings of Our Lord—but he didn't reserve them. There are some who say that if you talk about these things it gets discouraging and people will turn away and say it is too hard, as they did from Our Lord himself when he first said them. They say it is best to dispel the gloom, not make it worse, and stick to the cheery side.

I happen to have a small vocation for spread-

ing gloom; my favorite Protestant hymn, slightly
emended from the way it is sung even at Catholic
Masses today, is "Darken the corner where you
are!" because I think, though life is funny, it is not
for fun; and we have blurred the distinction be-
tween being happy and being blessed, confusing
the strong and sometimes bitter Catholic wine with
the juice of the Liberal Protestant grape. Anyone
who says that Christ will make you happy hasn't
tried him much, hasn't got even on to the *Camino
Real*, let alone very far along it, because the Royal
Way is the Way of the Cross. There is explicit
mention of Our Lord weeping several times; not
once do the Gospels say he laughed or even smiled.
"Gospel" means "Good News" in the sense that
we call Good Friday "Good".

This is not to advocate hypocritical affectation
of holiness like the Jansenist Tartuffe in Molière's
play who makes his famous entrance loudly calling
over his shoulder to the servant in the vestibule,
so all the ladies in the salon can hear,

Serrez ma haire avec ma discipline!
Put away my hair-shirt with my flagellator!

Quite the contrary, a sense of humor is part of the
Catholic sense—"humor" is from "humus", the
root of "human" and "humility". Chaucer, who
certainly had a sense of humor, and no one ever

accused of being gloomy, said we should "counter-feite cheer", we should "*make* merry", especially because we know that this life is a vale of tears. Shakespeare—whatever his religion, about which we know nothing—had the Catholic sense which measures true mirth and the bitterest reality.

> Blow, blow, thou winter wind,
> Thou art not so unkind
> As man's ingratitude;
> Thy tooth is not so keen
> Because thou art not seen,
> Although thy breath be rude.

> Heigh-ho! Sing heigh-ho! unto the green holly;
> Most friendship is feigning, most loving mere folly.
> Then heigh-ho the holly!
> This life is most jolly.

Catholic merriment is saying *now* and *at the hour of our death—Amen*. When at the hour of her death, St. Catherine cried, "Blood! Blood!" you may say she experienced joy in the perfect union in love with Our Lord, but it terrified everyone in the room and was certainly not what anybody ordinarily means by happiness.

Mary holding her dead Son in her arms to kiss those wounds like so many red lips—was it really like Michaelangelo's cool and pretty statue? I wonder could we look at her at all if she looked up at us with her burning eyes, scalded with tears?

The little girl at Christmas cries, "Look at the dolly under the tree, my prayers are answered!" And you say, "Yes, dear, God is good; he always answers our prayers." While inwardly, silently, you wonder—but mine? He hasn't answered mine. Isn't it true? At least if you have reached a certain age? And some reach it when chronologically quite young. But whenever it is, at a certain spiritual age, inwardly there is a sorrow, sadness, loss, an anxiety, and you become annoyed at all these happy Christians crying Joy and Peace, because there isn't any joy and peace for you at all. One day you say, silently, Lord, my prayers have not been answered. I've tried to do what St. Teresa says. I've looked and looked at you, and you do not look back. No one understands, not even you. I am alone. And then he says, Alone? And you say, Yes, alone. He says, Forsaken by everyone? Yes. And he replies, Now your prayers are beginning to be answered for the first time. You have just begun to be like me who cried out on the Cross the bitter Hebrew words which if you listen in the silence you can hear me cry at every Mass: *Eli, eli, lama sabachtháni*—my God, my God, why hast thou forsaken me?

At the Holy Sacrifice of the Mass, Christ himself speaks the words of consecration through the voluntary suicide of the priest's own personality;

the priest becomes the "persona", the instrument through which a sound is voiced; and Christ, not the priest, says *Hoc est Corpus Meum*. And that Body is lifted up in silence; the bell is the strike of silence; in a noisy world it takes a striking sound within whose widening circles noise is hollowed out. And then he says, *Hic est Calix Sanguinis Mei*. In the Garden of Gethsemane he had prayed: If it is possible, let this chalice pass from me. And now he says, This is the Chalice of my Blood. As we know, it is in the second part of the double act of the Consecration that the Blood of Christ is made present on the altar, separate from his Body, which is the reenactment of the shedding of his Blood at the Crucifixion. Blood is poured out under the appearance of wine, and the solemn bell proclaims it to a world which seldom listens. This is the Mystery of Faith.

There is a serious mistranslation in the leaflets currently circulating in the United States as substitutes for Missals. In the official text approved by the Vatican Congregation, the phrase *Mysterium Fidei* has a period after it, indicating that the words refer to what has just occurred, the central act of the Mass, the Consecration of Christ's Body and Blood reenacting in an unbloody manner, under the appearance of bread and wine, but actually reenacting, his Sacrifice on the Cross—this is the

Mystery of Faith. And in the Latin text there is a period right there. But in the English "missalettes" these words are followed by a colon, completely changing the reference, looking forward to the prayers which follow about the Resurrection and the Second Coming which are consequences of the Mystery of Faith and signs of it, without which, as St. Paul says, our Faith is vain; but they are not the Mystery Itself. The Mystery Itself has always and infallibly been taken to mean the real reenactment of the central act in the entire history of the universe from "*Fiat lux*" to the consummation of the world. As St. Paul says, Our Lord commanded the Apostles to "*do* this in remembrance", not simply to remember. At that moment in the Mass, even the Angels stop their song, a hush invades the courts of Heaven, and on earth there is darkness until the ninth hour.

> And behold the veil of the temple was rent in two from the top to the bottom and the earth trembled and the rocks were rent.

Though she was not a Catholic, Emily Dickinson was a Christian poet with the poet's intuition into the truth of things, especially, in her case, pain. She knew it well and wrote about it in astonishingly precise language:

After great pain a formal feeling comes—
The nerves sit ceremonious like tombs;
The stiff heart questions—was it He that bore?
And yesterday—or centuries before?

This is the hour of lead,
Remembered if outlived
As freezing persons recollect
the snow—
First chill, then stupor, then
the letting go.

"After great pain, a formal feeling comes." A poem always explains by making things less clear, like gauze covering a wound. The Holy Sacrifice of the Mass is the most formal act of which we have experience.

There is another "formal feeling", quite the opposite, of shame. St. Gregory the Great said:

> There are some who investigate spiritual precepts with shrewd diligence, but in the life they live, trample on what they have penetrated by their understanding. They hasten to teach what they have learned, not by practice but by study, and belie in their conduct what they teach by words. . . . Therefore the Lord complains through the Prophet of their contemptible knowledge saying, When you drank the clearest water, you troubled the rest with your feet.

Throughout the writing of this book—and I suspect the same is true of someone reading it—the gnawing question comes, Who am I to teach these things? I hear someone say, "Physician heal thyself." All my life I have worked by no means as well as I could, prayed less, and even in the little crosses, like Macbeth after murdering the King, have found that "I could not say Amen."

It is late. Late in my life, perhaps in yours—it is always later than you think—late in this twentieth Christian century. It will be very difficult to carry out even a tenth part of the Catholic Agenda: to live and work at an honest trade in a Catholic village, to reserve a tithe of time for prayer and to offer all our works, prayers, joys and sufferings in sacrifice to him. In fact it can't be done—except that we have his Blessed Mother's help. I have recommended E. F. Schumacher's *Small Is Beautiful*, Hilaire Belloc's *The Restoration of Property*, quoted considerably from *The Dialogues of Saint Catherine of Siena* (in Algar Thorold's translation) and from St. Teresa's *The Way of Perfection* (from Alison Peers' translation). If you read those books, especially the saints', you will not have read this one in vain.

Well, if unlike myself, you always do your best at honest work, practice steady prayer and accept the trials of daily life with a merry heart, the saints

say that at the hour of death the walls of your interior mansion suddenly become like crystal and the white radiance of the presence of God shines through. When you attend your own funeral, they say, the bells will sound like crystal glass, ringing like the laughter of angels, and you will see that real Pietà no artist has dared depict because no one could look upon it and live. And if you are more like me, and have not lived the Catholic life sufficiently, perhaps you will renew with me now the resolution to put these things on the Agenda and into daily practice, because the alternative is at best a suffering such as no pain on earth comes near, and the worst is eternal damnation. Pain here on earth, which seems to close down on us, descending like sheets of steel, is really the thinnest filament through which in death we pass as Christ entered the room where the Apostles waited, without even opening the door; or, as he was born of Mary, leaving her inviolate and perfectly intact. There, here, now—just through these visible walls of things, closer than our own breath, in the real Pietà, Jesus holds his Mother in his arms and wipes the tears forever from her eyes. She smiles, gazing on him.

It is no dream; but true. We know it is true because he said it was, who can neither deceive nor be deceived. If we practice a tenth or a hun-

dredth part of the Catholic Agenda now, then at the hour of our death, with Mary's arms uplifting us, we shall cry with St. Catherine, "Blood! Blood!" which is to say, "Amen". Work, prayer, sacrifice. That is the Catholic Agenda.

Holy Mary, Mother of God, pray for us sinners now and at the hour of our death. Amen.

CHAPTER IV

Theology and Superstition

It is increasingly difficult for conservatives to converse with liberals and for traditionalists even with each other. I haven't the credentials to settle these disputes and shall only try to tell my story, for the sympathy it might elicit in some understanding heart, like the coachman in Chekhov's tale who tries all New Year's Eve to talk to party after party of revellers and at last back at the stable confesses that his son has died to the tired old horse.

"Superstition" is something "standing over" from a former time which we no longer "understand". One of the popular anthropologists—I think it was Malinowsky—describes savages in Melanesia, cut off from the mainland parent culture for a hundred years, worshipping farm implements which they hung in trees, no longer having any idea of their function. The theology of St. Thomas has become something like that, a superstition among twentieth-century Catholics, including conservatives and traditionalists, his formulas, like rakes and hoes, hanging in our theological ginkgo trees; and it is no wonder that the younger generation has decided it is time to junk them.

A few uncommon and relatively unknown, and old, theologians still study and teach St. Thomas, but he is no longer received as the Common Doctor of the Church. The *Summa Theologica*, St. Thomas himself says in the Prologue, is a book "for beginners"; but we have few real beginners anymore. Our schools and colleges turn out advanced technicians in what are called the arts and sciences, but none has the ordinary prerequisites to traditional philosophical and theological study, none with the famous *mens sana in corpore sano* of the ancients, that is, disciplined in the perception, memory and imagination of reality. To compensate for our failures, seminaries in the decades preceding Vatican II tabulated maxims based upon the *Summa* as texts for easily testable courses run on principles remotely traceable to Descartes, full of method, and having little to do with reality, less of memory and nothing of imagination or the spirit of St. Thomas. In the great Catholic universities at Rome and elsewhere, the grand old Dominican and Jesuit masters went on lecturing in Latin to students, many from America, who had to get laugh-signals from the graduate assistants when the master cracked a joke because none knew Latin well enough to tell a joke from a scholastic formula. It is hardly surprising that in such universities scholastic formulas became

jokes. The only unusual skill you had to master at the Roman colleges, they say, was to read the easy Latin upside down because on oral examinations the professor would read aloud a question from the manual—holding it right there in front of him. If you had the trick of reading upside down you could give the answer word for word to pass with high distinction. Through a gross misunderstanding of docility, students sat on their disengaged intelligences through hours of what to them was gibberish, at the end of which they received gilded Italianate certificates in Canon Law and Theology certifying in reality an education of outlines, "ponies", and tests whose questions had been leaked in advance with answers right in front of them. And with these doctorates, as professors, rectors and even bishops, their graduates occupied positions of authority in Catholic universities and seminaries. Of course there were exceptions, but I think, brutal as it seems, this is a fair description of the general situation.

The results are still visible among the thinning ranks of priests formed before the Council. How else could the postconciliar failure have occurred? I heard a beloved example some weeks ago, whom I shouldn't disparage in any other way—a good man of the type of whom in terms of piety it is said in the Common for Confessors, *Euge serve bone,*

in modico fidelis! But, explaining the Eucharist to a parishioner who had been scandalized by uninstructed children secreting instead of consuming consecrated Hosts, he said, "Oh, St. Thomas teaches that only the accidents of the bread can be touched anyway, not the Body of Christ, which is the substance."

It is better, as Socrates repeatedly said, not to know and know you don't, than not to know and think you do. Or as the poet said (no matter how tediously quoted, the lines are true):

A little learning is a dangerous thing;
Drink deep, or taste not the Pierian spring.

Theology and philosophy are difficult, exacting sciences; there are few vocations to such studies in any given generation; and even for those with special gifts of intelligence and will, there are still twelve years of prerequisites in elementary and high school.

And of course this situation in the seminaries constitutes a kind of cream puff for the shrewd students of Loissy and Maréchal, some of whom must have perjured themselves in taking the Oath Against Modernism, who got themselves ordained under false pretenses and into positions of power, preparing the way for what Paul VI called the "auto-demolition of the Church".

And so I shall begin on a heavy note: There are always those who say we must cheer each other up despite the truth by urging "solutions" to what are termed "problems". But falsification is not the proper ground of hope, and reality is not a "problem" to be "solved", though it presents difficulties, some to be avoided, some to be faced. Anything else is not Christian cheer but folly.

I should rather cheer us up with the neat old truth that we are not meant to succeed in this world anyway but rather to do the job in front of us as best we can, because our Hope is in the next. The twentieth is not a convenient century for Catholic triumphalism. There is no possibility in the general loss of Christian Culture that we could build a cathedral like Chartres or write a text like the *Summa Theologica*—or even, except for a few, understand them. St. Thomas is still the Common Doctor of the Church but there aren't many common Catholics. The whole of Christian Culture, the seedbed of scholastic art and science, is depleted. We are in a dustbowl, as the Kansans used to say, and if you plant wheat, though it may sprout up, it will almost instantly wither in the drouth. There are many times in history, as in life, when the most difficult virtue of patience must be practiced with a cheerful heart; we must even, as Chaucer says, "counterfeite cheer", sure as we are

in the knowledge that, as Milton put it, in the sonnet on his blindness, "They also serve who only stand and wait."

St. Thomas called his life's work straw at the end, dying where he started out in a Benedictine cloister; but his was the real, tough, springy stuff, capable of bearing the kernel and the fruit of sanctity. Neo-Thomism in our own time couldn't even stand up to the grasshoppers of relativism and Social Darwinism. Nor could the few serious Thomists such as Garrigou-Lagrange propose a real theology to those who couldn't see beyond the rhetoric of popular science, which dazzled them with figures of speech in place of the quiet light of thought. Gilson recounts in one of his last, sad books, how he had refused a request from Pius XII to write a refutation of Teilhard de Chardin, whose manuscripts were, despite their condemnation, circulating surreptitiously among the young Jesuits—refused, Gilson said, out of no disrespect for a beloved pope, but because there was no clear doctrine in Teilhard to refute, only a kind of poetry which confused the imagination and affected the emotions but without argument, evidence or substance. Louis Salleron compared it with the occultist extravagances of the aging Victor Hugo. Maritain, in *The Peasant of the Garonne*, concurred; he confesses that all attempts to popularize St.

Thomas, his own included, had failed because there can be no substitute for intellectual light, for the primary intuition of Being. He himself, though this he did not admit, as soon as he stepped out of his expertise in theoretical philosophy and got into the practical art of politics, fell into the Modernist camp. But even Maritain, perhaps the best popularizer of St. Thomas, admitted at the end it had been a mistake. A student from the good days at Laval just after the War told me how at the end of a lecture on Aristotle, when someone asked for an easy example, Charles de Koninck simply lifted his outstretched hands in a silent gesture clearly meaning, "You must come up." One has to see the truth of principles, whereas popularizations, even the best, obscure as they explain.

So I do not advocate anything like a revival of St. Thomas. I think it is impossible under present conditions. He is better off where he is and incidentally needs no "revival" because he isn't dead; we're the ones who are dead, or almost dead; the rent is overdue and we are starving in a ruined tenement. Witness all the poets—Hopkins, Housman, Hardy, Yeats, Eliot, even Frost; and the prophetic historians—Spengler, Brooks and Henry Adams, Belloc, even H. G. Wells; witness the Hindu, Hassidic and Catholic prophecies of

recent years converging on predictions of the End of the Times of the Nations. The poets and prophets rather than the scientists and philosophers have that intuitive insight into the concrete; and they all say ours is an age of spiritual aridity, dissolution, a Dark Night of history and the Church. And anyone with the least sensitivity to culture can see for himself that we really are "the hollow men", in Eliot's poem and in De Chirico's paintings, like stuffed, stitched dolls, walking mindless among the broken statues of a devastated civilization. Nobody in his right mind would want to be "original" or "innovative" at a time like this. Which is why there is every reason for hope, because the saints all say that nights like this are darkest just before the dawn; they are stages in the growth of the soul. Father Hopkins wrote:

> And though the last lights off the black west went,
> Oh, morning, at the brown brink eastward springs—
> Because the Holy Ghost over the bent
> World broods with warm breast and with ah!
> bright wings!

"O night," St. John of the Cross says, "more lovely than the dawn!" It is a time when, cut off from the exterior consolations of the great, flamboyant, positive centuries like the fourth or thirteenth, those ages of artistic, political, scientific

—what we sum up as cultural—achievement, cut off from such consolations, living in a narrow, shallow, mean age of anxiety if not despair, in high-priced cheap houses—money itself is cheap —malnourished on denatured food, subject to totalitarian bureaucracies, guerrilla warfare, sniping, rape, materialist science, relativist religion and an industry devoid of art, the Christian soul is forced into patient, silent, interior receptivity to nothing but the agency of God. Noisy, shallow, arrogant types, misreading and misleading the times, rush around urging us to action, even to wild, public displays of prayer, in a silly show of rash, unfruitful and destructive activity, like the sailors on the way to Tarsis as Jonas slept in the still, dark hold of the pitching ship.

The age was symbolized for me when I arrived at a once magnificent Benedictine abbey to deliver a lecture to its seminarians. At the entrance gate, instead of the Porter prescribed in St. Benedict's Rule, who must greet each stranger as if he were Christ, there was an intercom system with an attached chart of names and numbers to call. After vainly ringing the monk who had invited me to speak, I wandered around the well-appointed grounds until a hardworking layman, with callused hands, raking gravel on a walk—probably not even a Catholic, certainly not a monk, but an

honest man—directed me to a building where he thought there might be lectures. Entering at last, I was greeted by an amiable prior or rector, smiling affably, dressed in his habit to be sure, holding a can of Coca-Cola in one hand and a cigarette in the other. Boccaccio would have enjoyed the scene but not St. Benedict, or even Chaucer.

> Let all guests that come be received like Christ, for he will say: *I was a stranger and ye took me in*. And let fitting honour be shown to all, but especially to churchmen and pilgrims. As soon, therefore, as a guest is announced, let the superior or some brethren meet him with all charitable service. And first of all let them pray together, and then let them unite in the kiss of peace. This kiss of peace shall not be offered until after the prayers have been said, on account of the delusions of the devil. In the greeting of all guests, whether they be arriving or departing, let the greatest humility be shown. Let the head be bowed or the whole body prostrated on the ground, and so let Christ be worshipped in them, for indeed he is received in their persons.

The rage for novelty and informality in everything today is a sure sign of our spiritual emptiness. Each week at Mass a confused, half-apostasized faithful face still another and another superficial innovation, as if turning the altar around, or serving Communion under both species or in the

hand could improve the terrible reality of Christ's Sacrifice. Baudelaire in that bitter, ironic book he called *Spleen*, almost as if he had the postconciliar Church in mind, explained that

> This life is a hospital where each patient wants to change beds around. One wants to suffer by the stove and another thinks he will be cured next to the window.

Philosophical schools like everything else come fast as fashions. In what seems to me a short life, I myself have suffered, since first intellectual awakening in the late 1930s, shocks of Marxism, split by Stalinism and Trotskyism; Freudianism, split by Jung-and-Adlerism; varieties of Bloomsbury Positivism and California Hinduism, Taoism, Zen, Existentialism, Neo-Thomism; every decade has its darling ingénue—Husserl, Heidegger, Wittgenstein, Sartre. Not to deny their brilliance, these are not fixed stars in the classical constellations but meteors flashing in the lengthening night of the Kali Juga. There is no steady, steadfast light of the great, long-lasting philosophical schools but the nervous, erratic glare of a smart, rapid putrescence.

I went to my movie of the year over the holidays, just to keep that much at least up with the times, and found something advertised as

decent enough for a man my age not to be embarrassed—there ought to be ratings like "Parents-admitted-if-accompanied-by-a-child"! It was a science-fiction show which ended with a scene in which an astronaut, apparently a descendent of the notorious "man from Racine", copulates with an electronic space-probe. The most popular of the current flicks popularizes Neo-Manichaeanism, an adaptation of the ancient heresy which teaches that God is both good and evil—the Force, the films call him. There is even a hint that the leader of the evil aspect is secretly the father of the young hero of the good, just as according to the Manichaean myth, Satan is the real father of Christ.

Movies are an index of the popular imagination and that's a long way down from Jules Verne or H. G. Wells. I have to lunch twice a week at the local Hamburger King. You know, of course, that millions of Americans now regularly eat French-fried potatoes with their fingers. We have sunk, anthropologically speaking, beneath the cultural level of the fork. The daily, unrecorded habits of a people are measures of its values. A disintegrated civilization shows not only in the low level of the arts, but in its pop entertainment and its lunchbox.

So I do not advocate a revival of St. Thomas any more than I should advocate building replicas of Mont Saint Michel or Chartres. This is not the

time of day, to say the least. Nothing short of a miracle could produce a great theologian today, and there is little reason to presume on that because while miracles operate beyond nature they do not happen without reason, and if a great theologian wrote today no one would understand him. The much more likely miracle to expect is the destruction of the Cities of the Plain. There is a proportionate analogy among the dominating forces of the age. Contraception and usury, as Dante knew, are contraries linked by the same ratio; the one renders sterile what is naturally fecund, the other fecund what is naturally sterile. Contraception and usury are the form and matter of industrial ideology, and unspeakable vice is its appropriate recreation. One doubts if God will find more sanctity among us than Abraham found respect for the norms of *Humanae Vitae* in Sodom.

Meanwhile it is a fact that the *Summa Theologica* is not only the greatest theological opus in history, just considering its size, integrity and scope. Anyone would have to say that; just to lift it puts it in a class with *Webster's International Dictionary*. But repeatedly affirmed by successive popes over so long a time, with no dissent, as an infallible teaching of the Ordinary Magisterium, the *Summa Theologica* is the norm and measure of all Catholic theology before and since. Catholics must believe

Thomas Aquinas to be the Common Doctor of the Church with the same degree of certainty that he is a saint. Saints Augustine, Gregory, Bernard, Bonaventure, John of the Cross and others are Doctors also, a precious, good, beloved, indispensable and intensely personal to many, but all are measured by the ordinary rule of St. Thomas and read by his light. I don't say *in*, because they have lights of their own, but *by* his light. St. Thomas holds a special place among theologians analogous to that of the Blessed Virgin among saints: he holds the mean between dogma and opinion, what we might call hyper-doxy, as Mary by hyperdulia holds the mean between veneration and worship. Unlike the Mother of God, St. Thomas is theoretically surpassable; and, of course, the Church has never taught that every syllable of the *Summa* is *de fide* like the Creed. The Church has never discouraged the study of other theologians, not even of heretics, since in their very errors they have twisted some truth which might never have been seen so clearly if they hadn't. St. Thomas himself laments the burning of heretical works; if only we had the precise arguments of Gnostics and Manichaeans, he says, how much better we should understand the Faith as explicitly opposed to this or that mistake!

Alas, as often happens, the command of the

Church was exaggerated and oversimplified in the execution. Instead of the difficult task of using St. Thomas as an instrument in the study of theology, seminaries largely substituted codified recensions of the *Summa* to be memorized, repeated by rote and sealed off from thought. There was, in fact, a fear of thought, a fear that weak and untried intellects might be seduced more easily by error than emparadised in the chaste, cold arms of truth. It is no wonder that in the generations of priests some of the liveliest chafed and galled and yearned for a live theology which they thought must be somewhere, anywhere, anyone other than this easily testable, detestable, set of upside down questions and answers called St. Thomas.

It must seem as if I am disparaging some good and faithful teachers of the Thomistic revival. But the failure wasn't theirs alone; nor do I think for a minute we have done as well; nor shall we see the equals in holiness and learning of Pères Boyer or Garrigou-Lagrange. But as their generation waned, bishops and seminary rectors accommodated to an increasing ineptitude in the students, which had resulted from the general collapse of Christian Culture in the industrialized world. The new young men came up from schools after the turn of the century for the first time since the Dark Ages incompetent in Latin

to begin with, and in all the Liberal Arts. Under the immense pressure of economic necessity, the elementary and secondary schools were fast substituting technical studies for the poetry, history and old-fashioned study of science called "nature-study" or "natural history" in which Aristotelian philosophy and consequently Scholastic theology had grown. The traditional college of liberal studies such as the Jesuit *Ratio studiorum* prescribed and Newman's *Idea of a University* celebrated, had been converted into a preprofessional training school for the technical sciences. I must emphasize the fact, too, because it isn't sufficiently admitted, that all studies at colleges and universities are now technical, even the study of literature, music and art. There are not two cultures as Sir Charles Snow suggested but only one. Though the matter of some subjects is humanistic, the formal approach is technical, consisting in methods of editing texts, historical classification, classification of types, linguistic analyses of style, psychological and sociological analyses of content. Seldom do you get the kind of literary study, for example, Mark Van Doren was famous for in the last generation, of direct appreciation of poetry as poets understand it and, of course, *a fortiori*, never the sort of appreciation of nature from a poetic point of view where the matter is scientific and the

formal approach, humanistic, taught by the great entomologist Henri Fabre. There is a poetry of poetry and a poetry of science which we have ruthlessly excluded from the curriculum in favor of total immersion in the science of poetry and the science of science. A famous scholastic formula says: *Ars sine scientia nihil*. We have found to our disgrace that *scientia sine arte nihilismus*. Science without art is not just nothing, it is nihilistic.

Twentieth-century seminary professors were commanded to teach St. Thomas to students who simply did not have the prerequisites; they were commanded to form the minds of seminarians regardless of the matter. So they didn't form, they shaped. Thomism became an empty shell and who could blame a few bright spirits if they pushed old Humpty off the wall and sought light among the gentiles and alienated Jews? What we need, they thought, is a new synthesis of the Catholic Faith and the spirit of the times. What St. Thomas did for Aristotle we shall do for Marx, Husserl or Heidegger, who are exciting and alive.

Consider the five hundred and ten Questions of the three great Parts, plus ninety-nine more of the Supplementum, so six hundred and eleven Questions averaging five or six Articles of the *Summa Theologica*—the weight, length, height, depth, breadth and the economy, not just the vast

extent but the intensity of single, marvelously constructed arguments, bursting with energy like fibers in the brain! For example, in the famous Question II of the Prima Pars, right near the start of the whole work, "Does God Exist?" Consider the capital text of Article III of that Question, *Utrum Deus Sit*; it covers two pages in the close-packed Marietti edition. In a thousand words, the entire five proofs for the existence of God; a scant thousand difficult but simple words as important in theology as Magna Charta in history or the battle of Thermopylae. Consider this vast and intricate achievement and then ruminate on the two hundred words of the Prologue (in the Benzinger edition):

> Because the Master of Catholic Truth ought not only to teach the proficient, but also to instruct beginners (according to the Apostle: As unto little ones in Christ, I gave you milk to drink, not meat—I Cor. iii, 1–2), we propose in this book to treat of whatever belongs to the Christian Religion, in such a way as may tend to the instruction of beginners.

Beginners? If this is milk who could chew the pabulum?

> We shall try, by God's help, to set forth whatever is included in this Sacred Science as briefly and clearly as the matter itself may allow.

"Briefly and clearly" in three thousand densely packed articles, each with its arguments pro and con linked by complex *Respondeo*s with their disclaimers and divisions, condensing whatever can be said in its degree of certitude of the teaching of the Church.

Now St. Thomas, if anything can be said with certitude of him, was not a fool. There must have been a considerable body of beginners ready for his book, students who had mastered philosophy and Scripture, the two immediate prerequisites to theology; and proximately, the prerequisites to those studies, the seven Liberal Arts—grammar, logic, rhetoric and the mathematical sciences; and remotely, as prerequisite to the Liberal Arts, the elementary training of the memory known by the ancients as musical education in the wide sense, including singing, playing instruments and dancing, literature, history and nature study; and finally, a prerequisite to music a vigorous training of the body in gymnastics, the purpose of which was not simply recreation and health but the acuity of sensing, as sight is sharpened and coordinated by archery; gymnastics is the first ground of all learning according to the dictum *nihil in intellectu nisi prius in sensu*.

It may at first seem mere Romantic puff to say that the first impediment to the study of St.

Thomas today is industrialized society. Generations brought up in centrally heated and air-conditioned homes and schools, shot from place to place encapsulated in culturally sealed-off buses, who swim in heated, chlorinated pools devoid of current, swirl or tide, where even the build-up from one's own pushing of the water is suctioned off by vacuums so as not to spoil the pure experience of sport-for-sport's sake; they play summer games like shooting balls through hoops, but re-invented as "basketball", and on winter nights, dressed in short pants; they play football under air-conditioned geodesic domes in heavy jerseys, and ski on artificial snow in July—poor little rich suburban children who have all these delights, and living in constant fluorescent glare, have never seen the stars, which St. Thomas, following Aristotle and all the ancients, says are the first begetters of that primary experience of reality formulated as the first of all principles in metaphysics, that *something is*.

Even Lucretius, who tried to conceive a universe of nothing but atoms and the void, had to admit into his mechanistic scheme a principle to explain why atoms ever touched—he called it swerve. There must be some inherent urge in atoms, he said, which of course ruins his whole scheme: If there is an inherent urge, there is something more

than atoms and the void. But today, I fear, a generation has grown up with no experience of swerve. When a child looks up to learn astronomy at the city planetarium, he spontaneously invokes a strange new psalm: The ceiling proclaims the glory of man! He is not even a pantheist but a pan-anthropist who thinks that everything is man. There is almost nothing not artificial in his experience—the fibers of his clothes, the surfaces of the tables and desks he rests his elbows on, the food he eats, the air he breathes, the odor even of his fellow inmates reeks with waves of artificially scented deodorant in this space-vehicle we have made of earth. Oh, not all of it, thank God, but of the parts we live in. It is comforting to know that still over vast tracts of the third world, and even of the second and first, the unwashed, ordinary, backward, unindustrialized peasant poor still await the self-destruction of our folly, essentially unchanged from the way they were that dark night when the shepherds saw the star which is still as near to us as his presence if only we were poor.

I said I fear this seems like hyperbole, literary stuff, an hour's entertainment after which we return to the reality of our daily routine, but this is just the point—our daily routine isn't real. Poets are not just entertainers; they are right about some-

thing. No serious restitution of society or the Church can occur without a return to first principles, yes, but before principles we must return to the ordinary reality which feeds first principles. Given a ruined intellect and will, we are most unlikely to do this voluntarily but only consequently upon some catastrophe toward which the poets and prophets converge—a plague, atomic war, explosion in the sun, whatever it will be, after which the remnant of the human race will look over the vast depopulated earth and say, God has given us another chance. And then the probability is someone will say, "This part is mine", and "this strange eventful history", as Shakespeare calls our lives, will start again. Meanwhile, there are a few who watch and wait.

Among the truths St. Thomas teaches as absolutely certain is the certainty and permanence of certain truths.

Jesus Christus heri et hodie, ipse et in saecula.

Those who deny or doubt the possibility of certainty have been disposed of often and well. The *Dialogues* of Plato have been written; no one will ever do them better; and however anyone did them, they would have to be substantially the same; and if a student having read them persists in scepticism, he has demonstrated his incapacity

for the further study of philosophy. In the large
sense there are achievements in action and thought
which have been accomplished; granted there are
many which have not. Those that have been done
cannot be done again except in the same way. The
wheel, for example, has been invented and if you
want to make another, adapt it as you may, make
it thick or thin, large, small, of wood or steel, if
it is a wheel it will have a rim, a hub and some sort
of connection between them. In the large sense
philosophy and theology have been done; granted
there are still important disputed areas, but the
continents are spanned, the general lay of the land
has been mapped. And yet there are those who
want to do it their way, differently, expending
their minds in a waste of shame, trying, as it were,
to reinvent the wheel. They want to have their
own philosophy and theology whereas the only
way that can be done is to make philosophy
and theology your own by understanding it. The
main lines of Catholic Truth are all in the *Summa
Theologica* and it cannot be done again. If anyone
were to do it (which is impossible today given the
loss of the culture that went into it, but even if it
could be done) it would turn out to be the same.
So there it stands, as vast, incomprehensible and
stupefying as Mont Saint Michel and Chartres.

Superstition, "standing over", as I started out

to say, is the precise opposite of "understanding". And for large numbers of Catholics today, not only the theology of St. Thomas, but the Faith itself has become a superstition. We give assent without belief, because belief supposes some degree of understanding. Faith, like science, without intelligence is magic. Many—most, under a certain age—at Mass now have little understanding of the greatest act in the universe, before which the angels bend their knees; with the loss of culture and the help of liturgists, most Catholics see it now primarily as a way of sharing the presence of Christ in each other, especially through a parody of the Benedictine kiss of peace. A sound priest I know taking over a new parish administered a test to all the children up through high school who had been trained in CCD classes. He asked where Christ is most perfectly and fully present and gave them three choices: in the Tabernacle, the Crucifix, in each other. The overwhelming majority underlined "each other". Some said afterward they thought the choices should have included the book of readings which the priest or lector always elevates at Mass as if it were the Host. Only two or three of sixty had even heard about the doctrine of the Real Presence of Christ in the Eucharist. To give another example, there have been scandals of "intercommunion" as it is called, in which

priests have deliberately distributed the Blessed Sacrament to non-Catholics on the grounds that since communion is an outward sign of an interior unity, by working the sign we might, backwards, effect the unity—reversing cause and effect—which is the precise definition of magic. A Sacrament, as we know, is a sign which effects what it signifies by the direct agency of God. Magic, the exact reverse, is the unlawful manipulation of signs in the absence of their cause; in magic there is no cause at all, but an illusion, which doesn't mean there are no effects due to other causes: the wizards of the Pharaoh matched almost all the miracles of Moses. Distribution of Holy Communion to those outside the Church may be a very efficacious malice if, without the excuse of invincible ignorance, non-Catholics received the Body and Blood of Our Lord to their own damnation.

When a brilliant young lady asked the greatest scholar in the world at the close of the fourth century where she could get the best education, St. Jerome replied, You can't because the world is through. And he advised her to enter a convent. A hundred years later, a bright young country lad came up to the university at Rome, lifted a foot to enter, but on an impulse turned and fled, not so much as having touched the polluted stair. A few years later, miles out among the hills, some

shepherds saw the bushes move: Was it a lion?
a sheep? When they parted the brambles, lo, it
was that country lad, St. Benedict. What are you
doing? they asked. Praying, he said. Why? they
asked. Because we should seek first the Kingdom
of Heaven. May we join you? they asked. And he
replied that they could if they asked three times.
They did and to make a very long story short,
in a thousand years they became Europe—St.
Augustine in England, St. Boniface in Germany,
SS. Cyril and Methodius and all the rest.

The word "monk" derives from *monos*, mean-
ing "one", "solitary", "alone", as in "monarch"
or "monotony". A monk is essentially a man
alone with God. When a few such gather together
the better to learn how to be alone, you have a
"convent", a coming together for convenience
of persons in a monastery, a place of essential
solitude. It was through the patient, silent witness
of monks at prayer over the Dark Ages that what
we call Christendom was achieved. St. Benedict,
Patron of Europe, founded Monte Cassino in 529.
St. Thomas as a little boy of five entered there to
go to school around 1229—seven hundred years
in the womb of Benedictine work and prayer
and then you have St. Thomas! The seedbed of
theology is the Benedictine life, without which
no one has the prerequisites.

Today we are, I think, in times like those of St. Jerome, moving rapidly toward those of St. Benedict. Barbarians have destroyed our cultural institutions, this time mostly from within; and now as then, it is true that there is nothing for the world to offer anyone. If I were a young man or woman seeking God today, I should enter, if I could, a Benedictine monastery. And if I were a Benedictine seeking God, I should work to reform my monastery so it conformed to the Rule of St. Benedict in its strict integrity, praying seven times a day the great Latin Office as recovered by the painstaking, sanctifying scholarship of Solesmes; and in the spaces between the hours, work with my hands at the immediate tasks of food and shelter. Or if I were called to the other vocations, the secular priesthood or marriage, I should become an oblate of such a monastery or at least keep as close to it as I could consistent with my obligations.

If I were pope, I should do just what it seems John Paul II is doing: If theology has become a superstition because the majority have lost the grounds of understanding, reform on a large scale is immediately impossible. In such a case, the thing to do is find the few extraordinary souls with special gifts of intellect and will, with the rational aptitude and zeal to learn; train them by

an intensified Benedictine exercise, put them on to the daily recitation of the Office, teach them the *Summa Theologica* as their daily work and then send these elite soldiers of the mixed orders as the shock troops of a general Catholic counter-reformation. If the Holy Father can succeed in the restoration of the Dominicans and Jesuits, he will have gone a long way toward implementing the real contents of Vatican I and II just as St. Pius V did for those of Trent.

And if I were God, like him I'd love my mother and for her sake have mercy on us one more time, which he will do, she says, if only we will fear him. And as Mary stands there at the Cross, so behind the preaching and teaching orders stand the silent, contemplative ones, without whose patience, active lives are ineffectual.

St. Thomas entered Monte Cassino at the age of five; he left for the University of Naples around age sixteen, entered the Dominicans, studied under St. Albert and became the greatest master of his Order and finally of the Church. Everyone knows how once in ecstasy before a Crucifix at Naples, or some say Orvieto, he heard Christ speak to him saying, "Thou hast written well of me, Thomas, what wouldst thou have in return?" To which St. Thomas replied, "None other than thyself, Lord." In 1274 he started out on foot, as he always did on journeys, this time for the

Council of Lyons, and fell into his final illness.
The Carmelites say Our Lady took St. Thomas
and St. Bonaventure, both at once, prematurely
up to Heaven because they were leaders of a
Dominican-Franciscan plot to do the Carmelite
Order in at the Council. Legend says that since
he was unable to walk, his companions placed
him on a donkey, himself protesting his unworthi-
ness to sit where once so great a Rider sat. The
Cistercian monks at Fossa Nuova gave him shelter.
On entering, he whispered: "This is my rest for
ever and ever: here will I dwell, for I have chosen
it", a verse from Psalm 131, which is sung at
Vespers for Tuesday in the Benedictine Office,
for Wednesday in the Dominican. The whole
psalm, beginning "*Memento, Domine, David et
omnis mansuetudinis ejus*", is a comment on St.
Thomas' life and especially on the importance of
St. Thomas in our time because he is the perfect
type of active intellectual who lived in the cocoon
of the contemplative life, spun out the tiny threads
of music, hour after hour, day by day through the
vigils of the nights, in the recitation of the Divine
Office, so that at his death he had the habit of
Eternal Life already formed. St. Teresa says in the
famous figure,

> [The silkworm] starts to spin its silk and to build
> the house in which it is to die. . . . On then, my

daughters, let us hasten to perform this task and spin this cocoon. Let us renounce our self-love and self-will, and our attachment to earthly things. Let us practice penance, prayer, mortification, obedience, and all the other good works that you know of. . . . Let the silkworm die—let it die, as in fact it does when it has completed the work which it was created to do. Then we shall see God and shall ourselves be as completely hidden in his greatness as is this little worm in its cocoon. . . . And let us see what becomes of this silkworm, for all that I have been saying about it is leading up to this. When it is in this state of prayer, and quite dead to the world, it comes out a little white butterfly. Oh, greatness of God, that a soul should come out like this, after being with him for so short a time.

St. Thomas was treated with such kindness at the monastery, he feared for his humility. "Whence comes this honor", he asked, "that servants of God should carry wood for my fire?" At the monks' urging, he dictated a commentary on the Song of Songs, which was left unfinished at his death when, directly addressing the Sacred Viaticum as he received It, he said:

If in this world there be any knowledge of this Sacrament stronger than that of faith, I wish now to use it in affirming that I firmly believe and know as certain that Jesus Christ, True God and True Man,

Son of God and Son of the Virgin Mary, is in this Sacrament. I receive Thee, the price of my redemption, for Whose love I have watched, studied and labored. Thee have I preached; Thee have I taught. Never have I said anything against Thee. If anything was not well said, that is to be attributed to my ignorance. Neither do I wish to be obstinate in my opinions, but if I have written anything erroneous concerning this Sacrament or other matters, I submit all to the judgment and correction of the Holy Roman Church, in whose obedience I now pass from this life.

And then his final words, once spoken by the Bride to Christ in the Song of Songs:

Let us go into the fields. . . .

Legend says that at the same moment, the donkey he had ridden broke from the stall, ran out into the fields and died—a Franciscan story of a Dominican Friar who died in a strict Benedictine House, in whom truth was united with love, which is the formal definition of Wisdom. I said St. Thomas didn't need revival because he isn't dead. He is alive and well, patiently waiting through those vigils of the night with everyone who prays the Office of the Church. Some of his own prayers are actually present there in several places, especially on the Feast of Corpus Christi:

the *Sacris Solemniis* at Matins, with the famous stanza beginning "*Panis Angelicus*"; the *O Salutaris Hostia* at Lauds; at Mass the sequence *Lauda Sion*; and at Vespers the *Pange Lingua* ending with the *Tantum Ergo Sacramentum* whose *responsorium* summarizes the sweetness of his love of Jesus to whose Presence in the Blessed Sacrament the words refer. We recall them not only from Vespers for Corpus Christi but also from Benediction:

Omne delectamentum in se habentem.

CHAPTER V

The Spirit of the Rule

At the height of the "greatest of centuries", when one of St. Dominic's hounds of God was attracting enthusiastic crowds to the new spirituality, the legend goes that he once stopped to converse with a nondescript soldier standing by a tree. People in the crowd were murmuring, "Who is that talking with Friar Thomas?" And someone said, "Oh, that's the King of France"—the King of France, of course, St. Louis, most of whose stories are like that, not really one of the great, public, spectacular saints like Paul, Augustine and Thomas Aquinas, men of extraordinary intellectual accomplishments and visible spiritual gifts, but despite the public life of soldier and king, more of the type of St. Joseph who slept during the second greatest event in the history of the universe. And of such a type too is St. Benedict, whose collected works fill up the scant dozen pages of a pamphlet, most of which looks like a timetable (which it is), as compared to, say, the twenty or thirty volumes of St. Augustine or St. Thomas. St. Benedict's life fills only another half dozen pages in the vast *opera omnia* of St. Gregory the Great—no one says St.

Benedict the great—but the fact of the matter is St. Gregory was a Benedictine monk who reluctantly became pope, and of his spiritual father he writes:

> If one wishes to understand in depth his personality and life, he can find in the dispositions of the Rule the exact image of all the actions of the master, because this saintly man is incapable of teaching other than he lived.

So there he stands as if beneath a tree in this humble, little, unadorned and unoriginal book, in a kind of burlap Latin, with nothing in the way of brilliant style or intellect or even it seems very much of spirituality. St. Gregory says of him in the famous antithesis that he was *scienter nescius et sapienter indoctus*. Dom Paul Delatte, second Abbot of Solesmes, in the best modern commentary on the Rule says of it that like the Ten Commandments of the Law it is *justificata in semetipsa*. It needs no style or intellectual or spiritual brilliance because, being what it is, it has transformed the history of Western Civilization, and more important, the heart of this man and that woman for fifteen hundred years.

With documents of profound simplicity, like the Bible itself, a single part will frequently subsume the whole, as for example the Prologue to the Gospel of St. John. The Prologue to the Rule

of St. Benedict, written last, the scholars think, as the final fruit of long, practical experience, breathes immediately the spirit of the whole; in it the range and depth of all the homely and eventful details which follow are virtually contained. The Prologue itself is virtually contained in the four imperatives of its first sentence, which I shall comment on only as they apply to members not of a monastic but an academic community, to us as practitioners of the liberal arts and sciences.

Ausculta, O fili, praecepta magistri. . . .
Hear, my son, the precepts of the teacher.

O fili. . . . As Dom Delatte says, "*l'appellation est caressante.*" It is the intimate, affectionate murmur of the *pater familias*, the loving father of the family, by the fire with the dog at his feet and the cat in his lap. Nothing is imposed; the teacher rather draws his student out; docility, as the Bride says in the Song, is an attraction—"*Trahe me*", she says, "Draw me"; it is as if there were some secret etymological conspiracy between *doce* and *dulce*.

Immediately in four discreet and quiet but vigorous imperatives, St. Benedict explains the condition, disposition, mode and motive of learning.

"*Ausculta*", he whispers. "Hear". And of course that means Benedictine silence. In order to hear one must be still, both without and within. The

first monk and paradigm of students was Elias who discovered, we remember, that the Lord of truth is "not in the wind . . . not in the earthquake . . . not in the fire . . . but—*sibilus aurae tenuis*—in the whistling of the gentle air", which goes in the French version, "*Douce comme un souffle de brise.*"

Though all this is familiar enough, it might be something of a shock for us not just to know it as we do a fact, such as the population of Chicago or the date of Caesar's death or even something more complex but of the same order like the economic causes of the Second Crusade, but to feel the force of the fact, supposing it were true: What would it mean really to have a silent mind? Silence is not just the absence of noise any more than peace is the absence of war. It is rather a positive and difficult accomplishment, a state of justice in the soul in which according to the classical formulation stretching back to Plato, each part receives its due in the performance of its proper function— the passions to give affective force in accomplishing the dictates of the will, the will to execute the commands of reason and reason to receive the truth; truth from without in abstracting essences from sense-particulars, truth from within in recognizing principles, and truth from above in obedience to grace. All that in the single word, *ausculta*—"hear". Those whose work is in the

liberal arts and sciences, as students and professors, must blush to be reminded that it is only to the just, gazing in rapt silence like a lover on his beloved at the art or thing, it is only to the patient, silent, receptive listener, that the meaning of the poem, or the mystery of the number, star, chemical, plant—whatever subject the science sits at the feet of—is revealed; whereas it was Bertrand Russell who summed up the arrogance of his technocratic clique in saying the function of science is "to make nature sit up and beg". Whatever place technology has in a society it should stand outside the precincts of the college, and it is a matter as important as the life and death of hearts not just to tabulate and classify but take and eat of the good, the beautiful and true.

> *Ausculta, O fili, praecepta magistri, et inclina aurem cordis tui.*
> Hear, my son, the precepts of the teacher and incline the ear of thy heart.

This means students must love their teachers and teachers must be worthy of such love. Learning is a motion of the heart and not a mercenary contract in the "marketplace of ideas" where the natural desires of youth to reach the stars are distracted from their aim by catalogues, orientation sessions and academic advising impelling them to market-

able skills and government grants. Wordsworth in his popular sonnet says,

> The world is too much with us, late and soon,
> Getting and spending, we lay waste our powers,
> There is nothing in nature which is ours,
> We have given our hearts away

The student who comes to his teacher and subject primed with what the modern university praises as the virtue of "critical intelligence", ruined by the shallow scepticism of Hume and Kant before he even starts, rejecting *a priori* anything which will not stand some superficial dialectical and arbitrary test to tickle his curiosity—such a student may acquire the technology of science and the humanities but he will never experience the reason for either. Such a critical intelligence, whatever its use in the marketplace, is prophylactic of the beautiful, the good and true. We must, St. Benedict says, and Wordsworth sings, bring rather to our subject "the heart that watches and receives".

> *Ausculta, O fili, praecepta magistri, et inclina aurem cordis tui, et admonitionem pii patris libenter excipe.*

"Accept the admonition of a loving father freely", not just the precepts and the counsels but accept the correction and rebuke of the teacher who stands *in loco parentis* as the strong, gentle, pious

father. Humility is a necessary condition of learning. The relation of student to teacher is not one of equality, nor even of quantitative inequality as between those advanced and less advanced on the same plane; it is the relation of disciple to master in which docility is an analogue of the love of man and God, from Whom all paternity in Heaven and on earth derives. This means that the purpose of study is not to work out "a philosophy of one's own", as is often said, but to learn philosophy. According to the Benedictine view, against the prevalent establishment, and exactly consonant with that of Socrates, St. Thomas, and Cardinal Newman, the purpose of a university is not—I say it sweetly, with reverent reserve—the purpose of a university is not research but friendship. Research, as the logicians would say, is subalternate to learning; it may function in an intrinsic ancillary role supplying illustrations and examples for the classroom and extrinsically might furnish some idea or object of marginal utility, as a carpenter sells sawdust or shavings to the iceman.

Ausculta, O fili, praecepta magistri, et inclina aurem cordis tui, et admonitionem pii patris libenter excipe, et efficaciter comple.

The student must not only receive the knowledge, counsel and correction of the teacher, he must

fulfill them, which means that he must understand, not just parrot or comply; and by learning, become assimilated to the spiritual, intellectual and moral model of the teacher. It is difficult to imagine such a condition today, but university faculty and students according to this rule should be better than the rest of the community, not only in intelligence but in manners, morals and taste as well. The university should be the exemplary image, not the servile reflection, of the community or worse its three-penny *galeotto* to what it calls various and unnamable kinds of liberation.

For a thousand years, Benedictine monasteries civilized barbaric Europe by example. You must, says St. Benedict in Our Lord's phrase, "be doers of the Word", and, in a word, be just men, not only study justice but thirst for it, beginning with and especially in yourselves.

> *ut ad eum per obedientiae laborem redeas, a quo per inobedientiae desidiam recesseras.*
> so that by the labor of obedience you might return to him from whom by the sloth of disobedience you fell.

The motto of the Benedictines is *Ora et Labora*; the besetting sin of the university is indeed *desidia*, an agitated indolence which pares its moral fingernails indifferently as an aggressive, brute bureau-

cracy cannibalizes the college. The pop carnality of student and faculty life which we gleefully confess to the opinion pollsters and statisticians is a braggart's cloak to cover an essential pusillanimity. Nor is it really the leftist chic though it grabs so much publicity. It has not been the *trahison des clercs* so much but that the clerks do nothing, like the King in T. S. Eliot's *Waste Land*, idly fishing in libraries and laboratories for as yet unpublished curiosities while the great, ordinary, saving precepts of justice and love are desecrated in our academic groves. *Perfidia* would be a worse and greater sin; it is *desidia*, alas, which is our *maxima culpa*. Look at the conditions under which we teach, the undignified, undecorated, humbug modern architecture and we call ourselves "masters of Arts". With what a servile stitch do we tailor courses to enrollment charts, the curriculum in fact to what is called "financial exigency", which means, of course, the aggrandizement of a shrewd administrative caste.

500 A.D. is a great moment of historical crisis and convergence, when the descending classical age, with its unifying culture and structure, met the rising, decentralizing forces of barbarism and conversion. With a prophetic power finely balanced by his liberal education, and deserving both the affection Lady Philosophy has for him

and the cult of sanctity sometimes paid to him, Boethius gives firsthand witness to the crisis which he met in two ways: First, successfully, he compiled encyclopedias—which literally means books for boys, not the indexed expertise of modern times; he simplified, synthesized and preserved the essentials of classical science which had become largely unintelligible to a generation on horseback fighting for survival in the fields. The Academy at Athens founded by Plato himself a thousand years before, closed at last almost precisely in the year Boethius became Consul at Rome. Against that fact, he had translated and written commentaries on Aristotle's *Organon* and the *Isagogue* of Aristotle's commentator Porphyry, and written textbooks of his own on arithmetic, geometry and music which became the standard source of scientific training for the next thousand years. Second, Boethius tried unsuccessfully to manage Theodoric the great Gothic dictator in order to maintain some semblance of the Empire and the orthodoxy of the Church; for this he was executed, some say martyred, putting his life as Socrates did to the test of Plato's sanction that the Republic is blessed if philosophers govern or if governors are philosophers. According to the *Consolation*, Lady Philosophy had commended his commitment to the double-vocation:

But thou didst decree that sentence by the mouth of Plato: That commonwealths should be happy, if either the students of wisdom did govern them, or those which were appointed to govern them would give themselves to the study of wisdom.

One can see in the mind's eye this human philosopher prince, holding the reins of a runaway civilization like poor Troilus,

infelix puer atque impar congressus Achilli. . .
unlucky boy, unequal in combat with Achilles, fallen backwards, with his foot entangled in the useless chariot, nonetheless holding the reins, his neck and beautiful hair dragging on the ground with his inverted spear writing in the dust.

E. K. Rand says, "Boethius was the last of the Roman philosophers and the first of the Scholastic theologians", and quotes the great adversary himself, old Gibbon, grudgingly admitting that the *Consolation of Philosophy* is "a golden volume not unworthy of the leisure of a Plato or a Tully" —strange word, "leisure", since the book was written in the death cell in the last days before his execution.

And exactly at the height of Boethius' academic and political effort, St. Benedict, *scienter nescius*, refusing to so much as set foot beyond the university gates, fled the city of destruction to the

deserts of Subiaco and Monte Cassino. They must have seen each other passing in opposite directions at the crossroads, Boethius last of the Romans, turning back to the last light of the blackening West; St. Benedict, first of the monks, hastening onward into the luminous East whence the Day Star rises, *oriens ex alto*. It was not the encyclopedias and the structure of Empire which saved civilization and souls, but St. Benedict's Rule.

According to the Song of Songs, Christ loves enclosed gardens filled with the color and fragrance of simplicity, poverty, chastity, obedience, silence and good cheer; and he loves sealed fountains welling up within with the living water of contemplation, leaping up unto Eternal Life. Both are figures of the Blessed Virgin:

> My sister, my spouse is a garden enclosed,
> a fountain sealed up.

The way to read the Rule is not to study but to pray it like a Rosary in little beads, over and over again until it yields its secrets. Much of it establishes the regulations for running the monastic house and farm; its practicality is measured by its astonishing success in fifteen hundred years of continuous exercise. For those of us in the secular life today, and not in monasteries, its use is chiefly in its regulation of the manner, form and

distribution of prayer. There are several ways of spirituality, some of them highly specialized for the select of any generation in Carmel or Charterhouse. Other ways as explained in Introductions and Exercises, such as those of St. Francis de Sales and St. Ignatius, are spiritual disciplines for those engaged in active work. St. Benedict's is best understood as the spirituality of *ordinary* life, based upon the fact acknowledged by all the masters of the *philosophia perennis*—Plato, Aristotle, St. Thomas —and the constant teaching of the popes and even according to Guénon and Coomaraswamy in Oriental tradition, confirmed by Revelation and proved in the common experience of mankind— that the vast majority of men are farmers. The great analogy of delving in the earth is prayer— elevation of mind and heart in praise—united in the single root of cult and cultivation. *Ora et Labora*. Work, from *erg*, en-*erg*-y, the force which moves the universe, finds its highest physical point in man who in labor transforms matter into praise as God through grace transforms both matter and spirit to glory. According to the Gospel, *Deus agricola est*, God is a farmer.

The Benedictine is a spirituality of work, man's by labor, God's by prayer. The Office of the Church, the *officium* or duty by which man pays his debt of praise to God for existence and grace, is

largely founded on the Rule. The recitation of the Psalter—sung to Gregorian chant—the hymns, readings from Scripture and the Fathers, the antiphons, are all mapped out in the timetables St. Benedict arranged to fit the changing of the physical seasons and the fixed and changing parts of the Christian year. The theory, not in the sense of hypothesis but of intellectual insight, of this way of spirituality is based upon the fact that there are two Revelations, the one in the Book of Nature where the visible things of this world signify the invisible things of the next, and the other of the Book of Scripture where the invisible things of the next are made visible in the life and death of Christ. Through intimate intercourse with nature in manual work and the absorption of his Presence in the Mass, and by *lectio divina* of his Word, the singing of the Office and a life in integral conformity with it, the entire person of the monk, body and soul, is transformed in Christ.

Manners, from *manus*, hand, are rooted in manual labor. The root is labor, the trunk and branches are the conduct of monastic life, the flower is the liturgy and the fruit holiness, all of which is visible in the posture, attitude, grace of gait, gesture, speech of monks, the whole of what in school they used to call deportment, and which St. Benedict calls "conversation".

Therefore must we establish a school of the Lord's service; in founding which we hope to ordain nothing that is harsh or burdensome. But if, for good reason, for the amendment of evil habit or the preservation of charity, there be some strictness of discipline, do not be at once dismayed and run away from the way of salvation, of which the entrance must be narrow. But, as we progress in our monastic life and in faith, our hearts shall be enlarged, and we shall run with unspeakable sweetness of love in the way of God's commandments; so that never abandoning his rule but persevering in his teaching in the monastery until death, we shall share by patience in the sufferings of Christ, that we may deserve to be partakers also of his Kingdom. Amen.

Processu vero conversationis et fidei, dilatato corde, inenarrabili dilectionis dulcedine curritur via mandatorum Dei.

Abbot Justin McCann whose translation I have quoted explains *conversatio* in a note:

This is the first appearance of the much-discussed word *conversatio*, which occurs ten times in the Rule. . . . In its account of the parallel (and more popular) word *conversio* the *Thesaurus Linguae Latinae* gives these two monastic meanings: (1) *introitus in vitam monachorum*; (2) *vita ac consuetudo monachi*. It is my considered judgment, after much study of St. Benedict's *conversatio*, that these two meanings fit it

exactly. I distinguish the two senses as Primary and Secondary and submit this scheme:

(1) *Primary Sense*. The word has an *active* meaning and denotes the monastic "conversion", i.e., the turning away from the secular to the religious life, the act of becoming a monk.

(2) *Secondary Sense*. The word has a *medial* meaning and denotes the monastic life as an established discipline and a regular observance.

At the same time, while we distinguish these two meanings the one from the other, we should be alive to the fact that there is a real continuity between them. Becoming a monk passes into being a monk; but there is the constant factor of the monk and his purpose. It may be said, indeed, that his whole life is, or ought to be, a prolongation in time of his original "conversion".

Dom Delatte, commenting on this same first occurence at the end of the Prologue, says,

Processu vero conversationis et fidei . . . L'habitude des observances monastiques, l'habitude de l'attachement à Dieu.

Conversation is "the habit of monastic observances" and that habit is defined further as "the habit of attachment to God". St. Paul, of course, had said, "Our conversation is in Heaven." First conversion to the monastic life is, as Dom Delatte says, that strict and difficult entering of the narrow gate, leaving the wide ways of the world. This is the

instant of actual poverty, higher than the call to spiritual poverty which is given to all; it is the instant of nonattachment, selling all you have and giving it to the poor, celebrated by St. Ignatius in the *Spiritual Exercises* and St. John of the Cross in *The Ascent of Mount Carmel*; it is the instant St. Martin gives his cloak to the beggar, of St. Francis running naked from his father's house and of the first Apostles dropping their nets to follow. But *conversatio* is also the second conversion, as Dom Delatte explains, not only of nonattachment to the world but to the habit of attachment to God which St. Benedict explains can have none other than a narrow start:

Non est nisi angusto initio incipienda . . .

almost the words of Christ himself:

Quam angusta porta et arcta via est quae ducit ad vitam!

Truth, St. Thomas says, is a relation of the mind and thing. The monastic habit is not simply physical and emotional. Founded on work and prayer, it is proportioned to the dual nature of man in his mind and body. Both work and prayer are intellectual habits relating the mind to thing, truth in this case being Christ, because the "thing" in this relation is God. Dom Delatte says that these two aspects of monastic conversation leave us

disencumbered and empty. The heart dilates, grows into the shape and form of God: God is at large in us, he is free and sovereign there. And our soul is also at

ease in Him. All our conflicts are appeased; there
is nothing now but joyous docility, a holy and sweet
confiscation of our will by the will of Our Lord, a
total joining to his lead. A jet of tenderness has
sprung up from the depths of our desert and its
waters having a sweetness without name, penetrate
like a liquid perfume all the way to the ends of these
devastated regions. It is the delicate touch of God
and his substantial kiss. And then the soul sets out,
it runs, it chants: *Dilatato corde, inenarrabili dilectionis
dulcedine curritur via mandatorum Dei.*

I shall never forget that afternoon, after a
transatlantic jet flight, a sleepless night—or day—
in Paris, long hours on the train and finally a
provincial bus which took us through the surpris-
ingly delicate little village of Descartes—which
as students of philosophy, we expected would
be mathematical and mechanized—on and on
through many a countryside and forest until sud-
denly, half asleep, not quite knowing how it hap-
pened, we were standing with our suitcases in the
dust before a massive stone wall with high towers
and roofs exactly as travelers stood a thousand
years ago here by the lovely Creuse where the
hermit Pierre de l'Étoile prayed, died and was
buried. The deep bells peal, answered by the little
highest one. I later learned they all have names.
And then, without transition, as in dreams (but

this is absolutely not a dream; this is the point, that it is all real) I am in the care, it almost seems the arms, of a zealous, smiling, slightly aging angel, greeting me with such affection, right out of the Rule, so solicitous of me I might have thought, if I didn't know better, that I was Christ! The Rule is not a book. It is a fact at Fontgombault.

The contrast with the rest of the world was all the more remarkable because at noon, four or five hours before, myself and the three young men with me—one is now a monk—had tasted the best of all possible worldly dinners at a provincial inn, with the tastiest *coq au vin* and *vin de la région*. The contrast was not between the worst and best but between the best a great, refined civilization can give and the least of a Kingdom not of this world.

The Porter had our bags, our arms, our laughter and bad French all caught up in his hands and merry eyes.

> *Ad portam monasterii ponatur senex sapiens, qui sciat accipere responsum et reddere, et cujus maturitas eum non sinat vagari.*
>
> At the gate of the monastery let there be posted a wise old man, who knows how to receive and respond, and whose maturity keeps him from wandering off. This Porter should have a room right by the gate so that those who come will always find someone there to greet them. And as soon as anyone

knocks, or if a beggar cries, he will respond *Deo gratias* or *Benedicite*. And with all the gentleness of the fear of God let him hasten to attend to them, promptly with the fervor of charity.

And there he is like one of Fra Angelico's angels, with a certain sweet reserve as if he knew some secret I was about to discover to my great good and delight, all exactly as St. Benedict specified and which I had always thought to be some ideal Republic like Plato's and never, not even in the Middle Ages and certainly not a present, reality.

Omnes supervenientes hospites tamquam Christus suscipiantur, quia ipse dicturus est: Hospes fui, et suscepistis me.
Let every stranger coming in be received as Christ because He it is Who one day will say, I was a stranger and you took Me in.

The spirit of the Rule is followed even to the ancient custom of the washing of hands. I remember coming up the line of guests to dinner when the Abbot, who after proffering his ring—one genuflects to kiss this signature of his great office, closest in perfection to a bishop's—pours what seems like silver—is it water?—over one's hands, as the tall, thin novice, keeping his eyes resolutely on the Christ within as if assisting at a Sacrament,

holds the gleaming bowl with the white towel folded over his arm. Manners are the foundations of morals as morals are of all exterior life. And on the principle that extremes mirror each other, manners also reflect the interior life of grace.

Without exaggeration, supper at this monastery, next to its liturgy—and eating is really a part of the liturgy like everything here—is the closest I have been to Heaven.

When Odysseus begins the recitation of his wanderings, addressing the lords and ladies at the palace of Alcinous in Phaecia, he says (in E. V. Rieu's Penguin edition):

> I myself feel that there is nothing more delightful than when the festive mood reigns in a whole people's hearts and the banqueters listen to a minstrel from their seats in the hall, while the tables before them are laden with bread and meat, and a steward carries round the wine he has drawn from the bowl and fills their cups. This, to my way of thinking, is something very like perfection.

Such a banquet in the *Odyssey* is in the secular order the pale reflection of an evening meal in the religious order here, which is not something like, but the life of perfection itself. It may be all the great events of our lives and of history—good and bad—take place at feasts. You could illustrate the

Odyssey, even though it surely is a tale of action if there ever was one, leaving out the action to describe the meals—Telemachus with the suitors in the great hall at Ithaca, and on the beach at Pylos where he meets Nestor and his sons, and at Menelaus' palace watching Helen as she descends

> from her lofty perfumed room, looking like Artemis with her golden distaff . . .

or Odysseus at the Cyclops' horrid feast, or with Calypso, or in Eumaeus' hut at breakfast, or at the climax of the whole poem as he draws the bow back once again in Ithaca.

The evening meal, at sunset, in the high refectory at Fontgombault is a solemn reenactment of the Last Supper. The long tables are arranged something like Leonardo's painting, with the Abbot standing before his little table on the end, beneath the Crucifix, as the monks file in along the aisles, heads slightly bowed. The Abbot solemnly intones:

> *Benedicite.*

And a hundred and fifty voices respond:

> *Benedicite.*

The Abbot then begins the verse, and all join in:

*Edent pauperes et saturabuntur, et laudabunt Dominum,
qui requirunt eum: vivent corda eorum in saeculum saeculi.*

The opening prayer concludes with a blessing
which reminds us that every supper here below is
an anticipation of the glorious feast of angels and
saints:

*Ad cenam vitae aeternae perducat nos Rex aeternae
gloriae.*

I was nervous my first few nights at dinner be-
cause everything happens so suddenly, without
transition, as it had on my arrival. All the life
here is like that. And it seemed to me that every-
thing was speeded up and not slowed down as
I had expected in meditative and contemplative
retirement, until I discovered that it wasn't speed,
but no time at all; they have transcended time. It is
an imitation of the Eternal Now when everything
occurs as Boethius said, *tota simul*.

There are the steaming bowls of soup, the fresh
picked vegetables, the plain, shallow dishes heaped
up like little Alps with soft white cheese some-
thing like yogurt, a glass of strong red wine and
fruit.

All during the meal in a high-pitched mono-
tone, half like a chant, a young monk reads the

history of a martyrdom. Except for him, strict silence.

> *Et summum fiat silentium.*
> And let there be the greatest silence, so that no whisper, and no voice but the reader's may be heard there. But for the things that they need as they eat and drink, let the brethren so supply them to one another that no one shall need to ask for anything.

It snowed next morning the early Easter Week I visited. Up for Matins in the pitch-dark cold, bundled in sweaters, I stumbled numb and half-awake down the old stone stairway to the cavernous Gothic chapel, absolutely dark except, at the far end, for the single red eye of the Sanctuary lamp. I could see my breath as something white and ghostlike, nothing else. Then the monks file in almost noiselessly, with a soft, rushing sound of their long angular habits, black on black in the darkness. Then a few small lamps are lit which seems if possible to increase the silence. The monks stand in their stalls which run down from either side like bleachers just in front of the High Altar. I can barely see them like shadows standing silently as fifteen candles are lit in the sanctuary. Then a sudden louder rustling as they kneel in silent prayer. All rise. Out of the semidarkness—I

can still hear it because it was not in time—a high, clear voice like a cry:

> *Zelus domus tuae comedit me et opprobia exprobrantium tibi ceciderunt super me.*
> The zeal of thy house hath eaten me up: and the reproaches of them that reproached thee are fallen upon me.

Three penitential psalms are sung, each with its hollow-sounding tones echoing up in the high stone vaults. I had always felt, listening to records and at concerts—even at churches—that Gregorian Chant was something rich and strange, but it is really *Plain* Chant, poor and familiar. At the end of each psalm a candle is extinguished, by the end of Matins all of them.

St. Benedict says in the Rule:

> We believe that God is present everywhere and that *the eyes of the Lord in every place behold the good and the evil*; but let us especially believe this without any doubting when we are performing the Divine Office. Therefore, let us ever remember the words of the prophet: *Serve ye the Lord in fear*; and again, *Sing ye wisely*; and, *In the sight of the angels will I sing to thee*. Let us then consider how we ought to behave ourselves in the presence of God and his angels, and so sing the psalms that mind and voice may be in harmony.

Now, in the First Nocturn on Holy Thursday morning, the first three Lamentations are sung in solo chant. I think, perhaps it is an angel.

Quomodo sedet sola civitas plena populo; facta est quasi vidua domina gentium: princeps provinciarum facta est sub tributo.

Plorans ploravit in nocte, et lacrimae ejus in maxiliis ejus: non est qui consoletur eam ex omnibus caris ejus.

How doth the city sit solitary that was full of people! How is the mistress of the Gentiles become as a widow: the princes of provinces made tributary! Weeping she hath wept in the night, and her tears are on her cheek: there is none to comfort her among all them that were dear to her.

When on Easter Monday it was time for me to leave at last, I turned back once more and said to the Abbot standing by the gate, "I really mean this, absurd as it may seem. Though I live in the United States and I don't know how it could be, I want to be buried here." And he gazed at me with that fixed look which the saints say is the look of Christ, and in Christ's tender wisdom, rebuked me: "It would be impossible in a monastic grave to be buried next to your wife." I knelt to receive his blessing. "For you and your beloved family," he said:

In viam pacis et prosperitatis dirigat te omnipotens et misericors Dominus, et Angelus Raphael commitetur tecum in via ut cum pace, salute et gaudio revertaris ad propria.

In the way of peace and prosperity may the omnipotent and merciful Lord direct thee, and the Angel Raphael be thy comrade on the way so that with peace, safety and joy, thou mayest return unto thine own.

It is true that monasteries are for monks, and I left in tears remembering with greater gratitude than ever the dearest gift and grace of my heart.

I shouldn't be so foolish or rude as to ask that anyone at universities give up his commitment to criticism—that would be a presumption, especially in my own deep ignorance of their expert skills which puzzle and confuse my naive love of the liberal arts; but I do suggest with due respect that in the interest even of their own accomplishments they turn their great learning once again to the humbler and greater elementary work of the conversion and education—the drawing out —of their students into the light of the good, the beautiful and true. Literary texts only live in the light, free space of the heart, soul, mind and strength of ordinary men, and these will be enriched, deepened and given a dimension only

when universities, as they once were, are tempered by the spirit of this Rule—not ruled by it; that would be to expect too much; but in the dominance of science and technology there must remain some silent time and place, some quiet groves among which a few at least may devote themselves to nothing else but forever unpublished knowledge and love in some little college-within-the-college on the old Oxford plan, whose purpose is not to use but to honor the past, a collegium, not thought of as "undergraduate", or "preprofessional", but as its own fruitful self. It is a shallow, shortsighted science which fails to see that science is grafted on such wood. What St. Benedict saw so clearly and set about to do with astonishing singleness of purpose is exactly what we have to see and do today: The purpose of a university, as any human enterprise, is to return to him from whom we fell, which means that a college is principally a place not of action but of that highest form of friendship which is prayer, where one becomes a friend of God's in the lifting of the heart and mind above subservience to self —even collective, democratic self—to him who first through the meek subservience of his Mother has been subservient to us. Though science modifies and even transforms reality, it cannot act

independently or in the absence of reality, which is why, with nothing but technology, we can analyze the Benedictine Rule and cite its literary sources, or take photometric measurements of Chartres and classify its parts and styles, but can't possibly write a text or build a building as high, deep, intricate, human and full of ultimate desire.

A Final Solution to Liberal Education

Controversies in education, as in anything else, are consequences of deeper divisions in philosophy and ultimately in religion. Disputes about general and special studies, the priorities of teaching and research or of the humanities and science reflect the oldest, bitterest warfare in ideas, exemplified in the death of Socrates. Socrates called it the fight between philosophy and sophistry; Aristotelians call it realism vs. relativism, because all questions come down at last to the assertion or denial of a reality independent of the mind which we can know by means of the mind with certainty. Relativism is the religion of the mass-media, including not only newspapers, magazines, books, radio, records, television, but alas, schools, colleges and universities as well, which have become, as it were, the seminaries of its priesthood, turning out the writers, editors, teachers, managers; and in the recent years of its establishment, this relativism has been imposed on everyone with all the inquisitorial force of a fanatical self-righteousness which, contradicting the major articles of its own creed, such as "academic freedom" and

"freedom of religion" or "separation of church and state", definitively excludes the realist view and especially its Christian expression which has been dominant in Western Civilization since the conversion of Constantine. Through the courts, in think-tanks and research institutes, in activist ideological organizations such as Planned Parenthood, the Humanist Society and the Civil Liberties Union, we have become victims in our public life of a mass agnosticism unknown anywhere in history, and worst of all, this spirit of relativism has paralyzed the Christian churches themselves, whose bewildered and diminishing flocks huddle in the fenceless folds while wolves in shepherd's clothing explain from the pulpit that the essence of tradition is change. Prayer has been excluded from public schools, and denatured in parochial schools, with the active connivance of ideological cells within the Christian ranks. The irony is not only the fact that organizations purporting to represent Christian churches have worked to exclude prayer from public life, but that it should be excluded precisely on the grounds that the Constitution guarantees religious freedom. Subtly and not so subtly relativism has established itself in the colleges where the Christian religion may be studied—provided that it is not believed. Christian texts may be examined as a type among others

in the pantheon, where all religions are compared according to the principles of relativist anthropology which can never conclude to the truth of any one; religion, including the Christian, is treated as if it were myth.

What we call the secularization of Christian culture, including the secularization of the Christian churches, is a consequence not so much of the loss of faith among the rank and file of Christians —Gallup and other polls repeatedly over the last couple of decades since the courts have outlawed prayer in the public schools show the large majority want prayer back, and the *latest* poll shows "eight in ten Americans believe that Jesus Christ is God or the Son of God," according to the Evangelical magazine *Moody's Monthly*. It is not the loss of faith among the people so much as the disintegration of reason among the managing classes, the judges, writers, teachers and especially the clergy. Reason is the matter on which the form of faith works; faith perfects reason in a manner analogous to the way a sculpture perfects a stone —but if the stone is pulverized, the form is empty air. An illusory, pseudofaith survives, like a puff of dust, under the loss of reason as a vague, uncertain sentiment, a wish, not even the will to believe of the Romantic philosophers, and *a fortiori*, not the definitive intellectual certainty of

belief itself. The practical consequence is a blind, cupidinous misinterpretation of charity as being "nice", as helping, sharing, playing kissy-kissy encounter games, neurotic, desperate substitutions for natural affection, confusing the soul with the skin, in a collective hedonism where the common good is redefined as interactive sensation: anything is right if it feels comfortable and provided it doesn't disturb the comfort of someone else. The greatest good for the greatest number is a kind of mutual adjustment in a communal waterbed. If one turns, we all turn; if one itches we all scratch, not quite sure whose rump is which. Any attempt to impose justice on oneself or others or on nations, is denounced as prejudice; even war in self-defense or to liberate a suffering, captive people is called "unthinkable", because thought has disappeared a long time since. Socrates in Plato's Dialogues, especially in the *Gorgias* and *Republic*, shows that justice is an intellectual virtue rooted in objective nature by which we know all good is diminished by any act against human nature regardless of how it feels. There can never be such a thing as a victimless crime because the one who commits a crime, even if in secret against himself, commits it against his own human nature and therefore, since all men share the same nature, against the human race. Suicide, for example, is an

attack on human life itself; to leave attempts at it unpunished or to honor its success, cheapens the lives of all of us. No one has absolute rights over his—or her—body. We are responsible custodians of our bodies and our souls according to a strict contract. Dante says the souls of suicides are metamorphosed into bleeding trees whose branches are perpetually broken because, as one of them explains, "it is not just that a man have what he takes from himself."

Particular persons are not the owners but the stewards of their lives, custodians, the tenants, as it were, and not the exploiting capitalists. Classical philosophy, the Christian religion and common sense are agreed that the only grounds for taking human life—never one's own—is in the defense of life or when justice demands that a capital crime be equitably punished. Justice is not a matter of desire or will, but a recognition of the way things are. Being and Good are convertible terms. *Ens et bonum convertuntur*. Realist philosophers have also always affirmed the existence of a necessary, infinite, intelligent Being as the ultimate explanation of a really existing universe. Realist philosophers who affirm this, do so in the natural light of reason alone; there is no need for Revelation in the matter of God's existence, though Revelation confirms it for the great ma-

jority who are not philosophers and haven't the time and ingenuity to think through the difficult arguments. In a common sense way it is true, as Revelation says, only a Fool denies the existence of God. Anyone in his right mind can see that all of this around us and including us is not a sufficient reason for its own existence. Either there is an ultimate Existent (which we call God) who is sufficient reason for existence, or there is no reason for the existence of anything—which is radical absurdity, and radical absurdity is not a reasonable alternative. No intelligent being can act in such a way as to deny its own intelligence; such an act can occur only by a deliberate act of the will darkening the intelligence, a perverse choice for which, as St. Paul said, a person is held responsible and to strict account. There is no choice between God and absurdity because no man can rationally choose absurdity. "The eye", as Wordsworth said, "cannot choose but see"; and the same is true of the intelligence which sees the intelligible content of reality and the necessity of its ultimate cause.

The beginning and middle of any order is determined by its end. The word "curriculum" comes from the Latin for running a race, and a race makes sense only at the finish line. Education today simply has no finish line. A college or uni-

versity is a collection of studies leading to several certifications—in history, literature, engineering, medicine, or whatever subject—but there isn't any final cause of the institution as a whole, no principle of integration, no "idea" of a university, in Newman's sense, no definition of the educated man, what Newman called the "gentleman", as opposed to the mere scholar, critic, scientist, technician. Like the nation itself, colleges and universities are propelled by the demands of the marketplace, pushed around by ideological pressure groups and limited by inertia—they have no definition.

Even the best colleges, such as the last survivors of the Great Books movement where they read "the best that has been thought and said", in Matthew Arnold's phrase, suffer from a failure in finality, opting for what amounts to the position of the philosopher in Lessing's myth who, when the gods offered him either truth or the search for truth, chose the search! Good as reading the Great Books is, even the best Great Books will fail without a certain rule of truth by which the conflicting ideas in the books can be judged true or false.

With respect and gratitude for my own initiation in ideas—and especially to one great teacher with "eyes slow and grave", at Columbia, still,

I have to say, alas, that even the Great Books movement so good in many ways is based upon a false rhetorical assumption: students simply don't have the prerequisites such an education supposes. Tutors in their seminars betray the sweet reasonableness they have espoused by introducing Plato, Aristotle or St. Thomas to unformed minds who haven't exercised and purified their imaginations first in the "child's garden of verses" as Robert Louis Stevenson called it—I mean the thousand good books that children and adolescents used to read before they tried the great ones. In my own direct experience teaching literature at universities, I have found a large plurality of students who find, say, *Treasure Island* what they call "hard reading", which means too difficult to enjoy with anything approaching their delight in *Star Wars* or electronic games.

I have taught Great Books myself for well over thirty years but have found larger and larger numbers—now, the overwhelming majority—of freshmen coming up from the schools who cannot read at anything like the proper speed, by which I don't mean fast, but at the speed where the mental concentration is on the wit and wisdom and even something of the taste and touch of what you might call standard college-level prose and poetry. What you get instead is a painful decoding

of hard sentences as if you were reading Latin. The publishers, aware of this, have turned out annotated editions which look like foreign language texts with copious rephrasing into the vernacular of television, *Time* and *Newsweek*—Easyspeak. We are at the point of facing-page translations of standard English literature. To cope somewhat with this, I tried to get college students at the age of twenty to fill in children's books they should have read at four, eight, ten and twelve—and discovered deeper still that the problem isn't only books; it isn't only language; it is things: It is experience itself that has been missed. No need to take the sentimental philosophy, but the prophetic fact the Romantic poets discovered must be faced. However strongly you reject his juvenile pantheism, Wordsworth is right when he says, "Come out into the light of *things*." There is no amount of reading, remedial or advanced, no amount of study of any kind, that can substitute for the fact that we are a rooted species, rooted through our senses in the air, water, earth and fire of elemental experience. *Nihil in intellectu nisi prius in sensu*. Perhaps you are tired of jokes about our plastic world, the unreality of Coke, potato chips and television shows. The Devil's neatest trick in a blasé world of easy change is to tease us into boredom with the ordinary, saving truths, which

are modishly discarded along with last year's styles. When you plant even the best children's literature in even the brightest young minds, if the soil of those minds has not been richly manured by natural experience, you don't get the fecund fruit of literature which is imagination, but infertile fantasy. Children need direct, everyday experience of fields, forests, streams, lakes, oceans, grass and ground so they spontaneously sing with the psalmist,

> Praise the Lord from the earth, ye dragons and all ye deeps, fire, hail, snow, ice, stormy winds, which fulfill his word; mountains and all hills, fruitful trees and all cedars; beasts and all cattle; serpents and feathered fowls. . . .

If they don't know the facts to begin with—not as something in the *National Geographic* or a zoo— they cannot learn to sing or love to read the children's literature which celebrates these things. And if without direct experience of reality and the love of it, you put them into a Great Books course you turn out smart, disputatious types with no real content to their agile arguments. Socrates all his life walked barefoot through the unpaved streets and steams of a large but still essentially rural village. You can see him in Plato's *Phaedrus*, bathing his naked toes in the cool stream as he

teaches a young, infatuated man the intelligible content of love. In the *Republic*, Socrates says, casually, that he had just walked the five miles down from Athens to the harbor and intends to walk the five miles back that night. Aristotle proposed a major principle in metaphysics while walking the twenty miles to Megara one day. St. Thomas Aquinas, brought up in the Benedictine monastery at Monte Cassino from the age of five, rooted in Medieval rural life, walked a dozen times over the Alps from Rome to Germany and back. You cannot use television shows and tape cassettes or astroturf or astrodomes to foster the healthy, natural gymnastics and poetry right reason presupposes. Nor, as I have said, is it just the bad contents of the media: We don't need bigger and better nature-shows by Jacques Cousteau. It is the artificiality of the television itself even when the material is supposed to be real. A sixty foot whale splashing across nineteen inches of your living-room while you sip your Coca-Cola is not reality. I remember how forcefully it came to me some twenty years ago that the real difficulty students were having with Chanticleer in Chaucer's *Nun's Priest's Tale* was not that, ignorant of Scholastic theology, they missed the satire in a rooster talking like St. Thomas—I could teach them the Scholastic theology at least to some

extent—but that never having seen chickens, they missed the fun in St. Thomas talking like a rooster! I remember, too, many years ago taking my then young children to the Bronx zoo in New York where we discovered at the end of the longest line not the expected Duckbilled Platypus but a farmer milking a Jersey cow—at which the poor little culturally deprived suburban children with starved, distended souls, stared and stared with wide eyes.

And let me stress again the role of the churches in this loss of reality, because if you look at the cultural life of the United States since its inception, the greatest normative control on language, music, art, morals, manners, on tone of voice and gesture, has been the ceremonious reading of the King James Bible, the Book of Common Prayer and Wesley's Hymns and/or the splendid Catholic Latin liturgy. In place of that, denominations according to their several myths, now distribute their respective communions in an atmosphere directly modeled on the way McDonald's distributes hamburgers, with the same music, costumes, charismatic smiles and for all we can tell of their intentions, sometimes, the same content to the apparent food and drink.

But even supposing there were a Freshman class discovered by some miracle apt for a Great Books

course, still, the question of finality remains. Without someone who knows what he is talking about a study of the Great Books and the great ideas they record is at best an intelligent but nonetheless desultory bantering. Learning is not for the sake of enquiry, enquiry is for the sake of learning truth. Even the best colloquium without certitudes to guide it is like the endless dialogue Dante describes so vividly and sadly in the Limbo of the good pagans, among those mild, luminous souls who, severed eternally from Truth, forever seek what they can never find, of whom Virgil, himself one of their number, says, *senza speme vivemo in disio*, without hope we live in desire. The whole passage at the start of the *Inferno* constitutes an exact description of Columbia's colloquium or the seminars at St. John's; in fact the list of interlocutors reads like their catalogue of books; in the Temple Classics Edition it reads:

> . . . We reached
> a meadow of fresh verdure.
> On it were people with eyes slow and grave, of great authority in their appearance; they spoke seldom, with mild voices.

> Thus we returned on one of the sides, into a place open, luminous, and high, so that they could all be seen.

There direct, upon the green enamel, were shewn to me the great spirits, so that I glory within myself for having seen them.

I saw Electra with many companions; amongst whom I knew both Hector and Aeneas; Caesar armed, with the falcon eyes.

I saw Camilla and Penthesilea on the other hand, and saw the Latian King, sitting with Lavinia his daughter.

I saw that Brutus who expelled the Tarquin; Lucretia, Julia, Marcia, and Cornelia; and by himself apart, I saw the Saladin.

When I raised my eyelids a little higher, I saw The Master of those that know [Aristotle], sitting amid a philosophic family.

All regard him; all do him honour; here I saw Socrates and Plato, who before the rest stood nearest to him;

Democritus, who ascribes the world to chance; Diogenes, Anaxagoras, and Thales; Empedocles, Heraclitus, and Zeno;

Euclid the geometer, and Ptolemaeus; Hippocrates, Avicenna, and Galen; Averrhoës, who made the great comment.

I may not paint them all in full: for the long theme so chases me, that many times the word comes short of the reality.

> The company . . . diminishes to two; by another
> road the sage guide leads me, out of the quiet, into
> the trembling air; and I come to a part where there
> is naught that shines.

In this crucial respect of finality the curriculum
at some Catholic colleges is superior to the older
secular programs they are modeled on; but even
so it would be wise for the Thomist philosophers
among them to recall the Scholastic dictum that
means must be proportionate to ends. The semi-
nar as a means of learning purports to be a dialectic
process derived from the Socratic dialogues. Even
if this were so—which a glance at Plato's text
proves false, and even if there were students pre-
pared for such a course—which a glance at their
reading habits proves ridiculous, but even if there
were such a dialectic and such students, without
the formal lecture and professors who draw not
just the questions but the right answers out, these
seminars slide down into bull-sessions in which
the strongest bull or the most artful dodger wins;
and if such sessions become habitual, they result
in arrogant scepticism, which is where Plato's
Academy ended. Students need systematic expo-
sition of ideas and hard, daily practice of logical
disputation under the controlled conditions of real
debate; and, without years of training in gymnas-

tics, music, poetry, art, history, and in manners, morals and religion, which used to be supplied by Christian homes and schools, the exchange of opinion in Great Books seminars encourages the very sophistry Socrates gave his life to combat. The student learns a critical method with which to demolish the ideas of others without having grasped any reality in the ideas at all and worst of all, if he has failed in the meantime to master his appetites and temperament—if he is weak, impatient, malicious, sensuous or indolent—with such critical weapons he is well on his way to Vanity Fair, where you get a Ph.D. and tenure.

The ancients distinguished four degrees of knowledge: the poetic, where truths are grasped intuitively as when you trust another's love; the rhetorical, where we are persuaded by evidence, but without conclusive proof, admitting that we might be wrong, as when we vote for a political candidate; next the dialectical mode in which we conclude to one of two opposing arguments beyond a reasonable doubt, with the kind of evidence sufficient for conviction in a law court or in a laboratory testing to certify a drug for human use; and finally, in the scientific mode—science in the ancient and not the modern sense which is dialectical and rhetorical, but science as *epistamai* —we reach to absolute certitude as when we know

the whole is greater than the part, that motion presupposes agency or know obvious facts such as Cuba is an island because we sailed around it. Each of these degrees has its appropriate faculties: poetry, memorization and imaginative play; rhetoric, precept and practice; dialectic, scholastic disputation and laboratory experiment; science, systematic exposition. But where does "class discussion" come in? Well, it isn't on the list at all, and not because the ancients didn't think of it, but because they rejected it.

In the sixteenth century when as John Donne said, "new philosophy called all in doubt", a fifth mode of knowledge emerged from the ruins of ancient and medieval thought which one of its brightest practitioners, Montaigne, called the *essai* —in French that means "attempt". Montaigne, a sceptic, was certain that there is no certainty, that intelligence is a kind of play and that truth is always nothing more than an *essai*. In the twentieth century, to make a long story short, as the cultural mood has moved increasingly towards the condition of the leisure state and all forms of activity are increasingly technologized, the essay has, like everything else, become collective. Discussion is our dominant mode of discourse as the committee is of government. As in "percussion" or "concussion", a "discussion" is the striking

against each other of several personal attempts at truth, of several personal essays—it is the energetic exercise of several intelligences together tumbling on a darkling trampoline. The most conspicuous loss to thought in such a system is that no one ever listens. All participating minds are hyperactive. No sooner is a phrase flung out than—snap!—a critical question. "What do you mean by truth?" "What do you mean by mean?" "What do you mean by what?" There is no slow growth of the mind, as Wordsworth called it, nothing of the pastoral spirit of the real Socratic dialogues, none of the rumination on a truth that saints recommend, no meditation as the beginning of contemplative understanding—in fact no understanding at all; all instead is "standing over", literally superstition, in which the mind is the master not the disciple of reality. According to such discussions, man is the measure of all things, as the sophist said. Niels Bohr, the atomic physicist, summed it up in an appalling confession of philosophic apostasy: "Every sentence I utter must be understood not as an affirmation but as a question." The god of the collective essay is change, and through the essay and especially the collective essay in our time, change is established as the immutable god of governments, universities and even religious covenants and convents.

The so-called seminar is the application of the collective essay to all four modes of knowledge and is appropriate to none of them. Good teachers, let me hasten to add, despite the technique, ignite the minds of their students when the virtual fire in texts is struck to actuality by sparks of their own will and wit; it "will out", as Hopkins says, "like shining from shook foil". I've seen it happen again and again as you do in the Dialogues with Socrates, when a good teacher, carried away by the sight of beauty, good or truth, cuts through the "I think, you think", to prophesy like Jeremias with the overwhelming doom of certitude, which settles over the silent table like the descent of the Dove, and we repent our egotistical opinions and values and blush in the shame of pure, simple, incandescent assent. "That is true", we say, "that is really true." And that is the experience you never forget in a real liberal education, and when it happens once you will suffer hours of failure and frustration in seminars and class discussions in the hope the fire will strike again. And if that has never happened, you haven't had an education at all.

One of the best immediate improvements in the whole of contemporary life, including education, would be a moratorium on chitchat. No more essays, single or collective, no more discussions,

committees, newspaper columns, talk-shows, re-
ligious dialogue, conferences and think-tanks. If
someone knows something, if he has authority,
let him explain as much as and to whom he sees
fit and everyone will listen and shut up—except,
of course, women, who have a special prerogative
—but, no! especially women, because they have
the highest gift for silence: The greatest contri-
bution to the restoration of order in all human
society would be the founding in every city, town
and rural region, of communities of contempla-
tive religious committed to the life of consecrated
silence, so that silence would be present to our
works and days like the vigilant umpire at a game,
to judge and measure all our noisy accomplish-
ments. The chief reason why sex is tearing itself
to shreds in all the violent varieties of induced
sterility is that very few are leading lives of con-
secrated, fecund virginity; and the chief reason why
our discussions and committees have concluded to
the sterility of scepticism is that fewer still lead
lives of consecrated, fecund silence.

Education in the 1960s largely left the limbo of
St. John's and the other Great Books colleges to
descend by another, faster road, deeper into Hell,
to the part where "there is naught that shines"—
which is worse; and yet it may in the long run
be the better way because things must get worse

before we shall ever see the light by which to make them better. The long way out of the radical dis-education of our time will be found, I think, only by those who get to the bottom of the labyrinthine university and there distinguish, as Dante said of the bottom of Inferno, "through a round opening, the beauteous things which Heaven bears and thence again to see the stars."

For the five hundred years since Hamlet pushed it over the brink, Western Civilization has been on the downward path of doubt, where "to be" becomes a question. When Moses asked "Who shall I say sent me?" the Voice in the Burning Bush replied, "Tell them 'To Be' sent you—He Who Is." And that was no *essai*, but certitude, not a doubt but the ground of both Faith and reason and the final reason for all this strange eventful curriculum called human life.

Suppose that God is not a feeling but a fact. If he exists, that makes a difference, not just about some things but everything, including ethics, politics, science, literature, engineering, business and religion, in a word, the *cursus completus*, the entire curriculum.

From the atheist precincts of Buchenwald, the Gulag Archipelago and the dark, satanic mills of the mass-murder of unborn children in the United States, the final solution to Western Civilization

is its extermination. In the intellectual sphere this solution has been the dissolution of knowledge into its specialized departments, class discussions and committees, so that the teacher no longer takes his ideal from Aristotle as the master of those who know, but from Hamlet and Descartes, the masters of those who doubt—who test, experiment and publish and never conclude but *essai*, whose "truth" is always in quotation marks, for whom the perfect unit of expression is not the sentence but the parenthesis.

But if God exists, there really is a verb "to be"; verbs assert existence and therefore there are sentences; and if in addition to existing, God reveals and saves, then there are sentences of eternal life and death. And certainly if he exists, *a fortiori* if he reveals and saves, he cannot be excluded from the curriculum—except by that deliberate act of willed ignorance which St. Thomas says is the essential element in sin. Socrates said evil is a kind of ignorance, which is true because the words "ignorance" and "ignore" have the same root, but to ignore is not just to lack knowledge; it is *an ignorance on purpose*, not simply an absence but, as St. Thomas says, *to act* under a deliberate nonconsideration of the rule which you know perfectly well. In the treatise *De Malo*, he says,

Thus it is that the artisan does not sin in the fact that he is not always holding the rule in his hand, but in the fact that while not holding the rule in his hand he proceeds to cut the wood.

Not to have a college at all would mean an ignorance of many things, but to have a college in which the faculty and students form a compact to leave God out is not just the privation of a large branch of knowledge; if you leave out God, the existential, actual cause of everything, you are not just in ignorance but have committed what St. Thomas calls the intellectual sin of certain malice. If eight of every ten Americans believe that Christ is God, you would expect that eight in every ten colleges would be founded on that divine majority, whereas it is just the other way around; even in nominally Christian institutions, and obviously in the rest, the curriculum is founded on a rigorous exclusion of any certain truth, which amounts to an inquisitorial establishment of pluralism.

Questions about curricula are reducible to the final questions of philosophy, which are religious. Suppose that God exists and there will be a necessary order in nature and in all the sciences and arts that study and imitate nature. Suppose further that

God reveals and there will be a necessary content to knowledge not otherwise known, which will not only be a new knowledge but, since it is superior and architechtonic to the rest, the rest must be consistent with it and be interpreted in its light. Suppose further—which is impossible to suppose as a pure philosophical proposition, but history has proposed it as a fact—suppose God saves, that he became a man, dwelt among us and gave us through his sacrifice the means of participating in his own life, which we call Eternal Life, as he is in himself as the final, never-ending end of our existence—supposing that, you have not only got an order and a content but a *praxis*, a set of things to do, not just to think, an agenda which is no longer a matter of temperament or choice or life-style but a definite course of things which must be done in which learning and all other kinds of activity become prayer, a sacrifice of praise *ad majorem Dei gloriam*, for the greater glory of God, in the famous phrase of St. Ignatius Loyola, who founded the best system of Christian schools and colleges in history, for which he set down this as the First Principle and Foundation:

> Man is created to praise, reverence, and serve God Our Lord and by this means to save his soul.

This First Principle and Foundation sets up a new

economy by which to measure schools, curricula, subjects, teachers and students; if you accept it, not just something but everything will change. Anything less is futile and worse than fruitless because if God exists, reveals and saves, those who refuse his means not only fail to reach the end but will enjoy the bitter fruit forever of their malice.

An agnostic university exactly imitates Lucifer in his fall, as Jacques Maritain describes it in his remarkable little book, *The Sin of the Angel*:

> Thus the Angel fixes himself in evil. Not wanting any part in the supernatural beatitude for which God made him—because in spite of all his splendor he would have to acknowledge himself little in comparison with it—he sins against the supernatural order and at the same time against the natural order (which prescribes obedience to God always). He has made himself his own beatitude and he will remain in this attitude, at the price of the pains of hell, which he has accepted in advance. He prefers this sort of beatitude—solitude in his own nature and self-sufficiency in evil and negation, and pride in being able to impose privation on the (antecedent) will of God. . . . He has what he wanted. The act in which he chooses evil and refuses charity is his first act of liberty. He is fixed in it forever because the free decision of the Angel is essentially irrevocable.

The free decisions of men and their universities

are not irrevocable, so long as we are here below
—though I admit that what Christian Revelation
demands is impossible to realize without a miracle.
But if the Christian Revelation is true the final
solution to the problem of liberal education as
with anyone or anything else is its conversion,
which means first, opposed to the sophistical
fictions of "disestablishmentarianism", the frank
acknowledgment that all things must be done
AMDG—for the greater glory of God.

I am not denying unbelievers the right to have
their schools, but it is an absurd interpretation of
justice that Christians should exclude themselves
from their own schools on the grounds of being
fair to unbelievers, as if those who can see should
pluck out their eyes to give the blind equality.
Secular education is not only incomplete but con-
trary to both God and nature; it is sacrilegious and
unscientific.

Second, the conversion of education means the
recognition that the ultimate formality of what-
ever subject is studied is the mind of God as it is
revealed in created things, physical, mathematical
and ethical, and as it is imitated in things pro-
ductive, so that God himself is always our only
subject, which is not to deny the real distinction of
the parts. And third, the structuring of learning
must follow the order of nature and of the learner

from sensible to imaginative to intelligible knowl-
edge. Gymnastics, music in the wide sense and
science follow in that order and cannot be skipped,
reversed or mixed.

According to a saying of the Scots, "A fish
always rots from the head down." The crisis in
leadership today is a national catastrophe. We
are suffering under the reign of an ignorant but
shrewd bureaucratic mediocrity whose sole atten-
tion is always focused on its own advancement,
which makes it easy to push out of the way those
whose minds are on the job to be done, those who
sit up nights pondering the mysteries of physics
and the human heart and days wrestling with the
restless and reluctant minds of youth.

But faculties have no right to complain. The
faculties of universities have betrayed their trust,
which is to transmit to new generations the great
deposit of the good, beautiful and true which
we know as Western, more properly, Christian
Civilization. The "treason of the intellectuals" has
been a sorry, sad, sordid affair.

Parents who entrusted their children in good
faith to universities found them sold by smart
Fagins in the markets of twentieth-century slavery
—Marxism, behaviorist psychology, drugs, por-
nography, sexual perversion. It is no wonder that
citizens in revulsion took the other tack. If *that*

is liberal education, they said, let's have a trade school only and stay out of ideas altogether, with a safe administration which prevents evil by stifling the root of evil, which is thought!

It was a bad mistake. It played into the hands of the enemy, laughing in the wings. The purpose of a university is not staying out of trouble. Error is trouble, yes. But so is truth. What we need are good strong deans, presidents and faculties with a Christian liberal education themselves who have the courage to go back to start and start again on the right and only First Principle and Foundation.

The university, like business and the nation, desperately needs leaders—and followers—with real knowledge and love of truth, gentlemen, scholars, with something of the soldier in them because it will be tough to reverse so many habits of cowardice and weakness, disguised by quantifiable appearances so that the number of pages of printed research regardless of quality is rewarded with highly-paid professorships, grants, sabbaticals, while good teaching is damned with faint praise and token, one-shot schoolboy prizes outside the system of serious academic advancement. The best teachers in any university rank almost without exception in the lower half of the pay scale, while the worst occupy prestigious chairs.

What are the chances of reform? Why, schools and universities will reconstruct from the rubble anytime, anywhere anyone starts again from the right beginning. What is true is true *semper ubique idem*. We get the government and the education we deserve, and we shall get effective leadership when we really call for it, which means when as a nation and locally in neighborhoods and in the home, we have sight of the goal. You can't reform the means until you know the end and that is finally the religious question. Unless the nation, starting with neighborhoods, homes and hearts, returns to its Christian origin and end, it will disintegrate. For leadership in every walk of life, we simply must have saints, who are ordinary men and women driven to heroic virtue by the love of God. And we shall find them when we want to; there might be some reading these very words and wondering if it were someone else, some St. Cecilia or St. Francis, unknown perhaps as yet to themselves, their great vocations hidden in their own hearts like gold in a deep vein. Restorations never start at the collapsing top but always in the dull low places of simple hearts, not in the roaring of the wind but in the whistling of a gentle air.

When a nation takes nothing but material success as its measure of value, it is led by the mean

mediocrity which has us in its grip, stifling all initiative as we await the more effective aggression of foreign powers motivated by deeper loves and hates, who are willing to sacrifice their comforts and even their lives for what they believe.

The Darkness of Egypt

They say that in the catacombs which run for hundreds of miles beneath the streets of modern Rome, deeper than the wine cellars, down below the Vatican, there are barrels, jars, packing cases, crates and caskets of uncatalogued and unevaluated relics, some claiming to date from Paradise —Adam's thighbone and the rib he shared with Eve, bones of known and unknown saints and fakes, falsely labeled pigs' bones and dozens of rival crania all claimed to be the skull of John the Baptist, bits of clothing, dried up clots of blood which liquify on certain days—and among them, they say, was a small, sealed, glass phial, stuck down there among the cobwebs and mold, accidentally discovered by a novice of the Order assigned to the Office for the Verification of Relics, who, searching for an authentic, first-class bone, inadvertently knocked it over.

The young monk held his flashlight closer. Seized by a nervous curiosity, he broke the seal and pried out the little cork. His fingers felt a damp, peculiar ooze which made his flesh crawl, as if he had touched a slug, though there didn't seem to

be anything there. Holding the flashlight to the label, he read the carefully scripted Latin uncials: *Tenebrae Aegypti"*—The Darkness of Egypt—and in finer script, these verses from the Book of Exodus:

> And the Lord said to Moses: Stretch out thy hand towards heaven: and may there be darkness upon the Land of Egypt, so thick it may be felt. And Moses stretched forth his hand towards heaven: and there came horrible darkness in all the land of Egypt.

The young monk threw the phial down; it smashed on the wet stone pavement; and he fled in terror, as up through the sewers to the streets and into the gum soles of shoes and into living bones and brains, the darkness spread—through Rome, Italy, Europe and the world.

Well, that is just a story, merely fiction. But perhaps, as stories sometimes do, it tells us more than a tale.

The secular religion most widely spreading in the Western world, and even in the Christian churches today, is often called Humanism. Can there be a Christian Humanism?

Ism in the strict sense means an adherence to a person, cause or thing to the exclusion of everything else and to excess. Isms are results of the one-track mind and produce the fanatic. The

word Humanism was first applied to the work of some scholars and scientists of the Renaissance who rebelled against what they considered to be an excessive adherence to Scholastic theology and the science of Aristotle, which new observations of nature—especially with the invention of the telescope and the dissections of anatomists—rendered, they said, obsolete. Though there was a tendency among these scholars and scientists to rebel against the Christian religion itself as part of the so-called outmoded world view, still that was not true of all Renaissance Humanists, some of whom defended the Faith on the basis of the new scholarship—Erasmus, for example, who wrote tracts against Martin Luther, and St. Thomas More who was both a Humanist and a martyr to the Faith. But in general, Humanists (as the word itself plainly says) centered their philosophy on man and the things of man to the exclusion of God. Shakespeare sums up the theme in Hamlet's speech:

What a piece of work is man! how noble in reason! how infinite in faculties! in form and moving, how express and admirable! in action, how like an Angel! in apprehension, how like a god! the beauty of the world, the paragon of animals.

Hamlet, of course, touched by tragedy, sinks into

the complementary opposite stance of a deep, implacable pessimism, which was typical of Renaissance anti-Humanist thought. It was a divided, antithetical age. After Hamlet speaks these lines in praise of man, he adds, ironically,

> And yet to me what is the quintessence of dust? Man delights not me; no, nor woman neither.

And everyone remembers how, in another more famous speech, he contemplates suicide, saying of himself (but he speaks for the age as well) that he is

> Sicklied o'er with the pale caste of thought.

Shakespeare saw with the poet's penetrating eye that though this creature can be in action like an angel or a god, this paragon of animals is more frequently less than a beast. St. Thomas More and his friend Henry VIII shared the new philosophy, both were Humanists; one became a saint, the other something less. Henry's daughter "Good Queen Bess" could turn a Latin hexameter neat as Virgil himself and command with the dispatch of Salomé the heads of saints. Evelyn Waugh in his brilliant biography of St. Edmund Campion describes this exact juxtaposition of sophisticated scholarship and science alongside "vile and gross" moral and physical cruelty:

> Sir Francis Knollys, Lord Howard, Sir Henry Lett and other gentlemen of fashion were already waiting

beside the scaffold. When the procession arrived, they were discussing whether the motion of the sun from east to west was violent or natural; they postponed the discussion to watch Campion, bedraggled and mud-stained, mount the cart which stood below the gallows. The noose was put over his neck. The noise of the crowd was continuous, and only those in his immediate neighborhood could hear him as he began to speak. He had it in mind to make some religious exhortation. "*Spectaculum facti sumus Deo, angelis et hominibus,*" he began. "These are the words of St. Paul, Englished thus: 'We are made a spectacle unto God, a spectacle unto His angels and unto men,' verified this day in me, who am here a spectacle unto my Lord God, a spectacle unto His angels and unto you men."

No one listened. In minutes, they hanged him, drew out his entrails while he was still alive and cut his body into quarters which they nailed to posts in the four districts of the city "as a spectacle to men".

Ism, as I said, is an adherence to the exclusion of everything else and to excess. Among its varieties of meaning, the *Standard College Dictionary* cites, "Ism—an abnormal condition resulting from an excess of: alcoholism." Well, Humanism is an excessive and exclusive addiction to the human, and like alcoholism, it is either a vice or a disease.

"*Homo sum, humani nihil a me alienum*", the

Roman poet Terence wrote: "I am a man, and nothing human is alien to me." Well and good so far, but when you concentrate on man alone, then God becomes alien. The difficulty Catholics have with Humanism is not that we are human; it is with the ism, any ism, because the Catholic, meaning universal, religion is ordered to the Author of infinite and integral Being, from Whom nothing is excluded, nor, since he is the Infinite himself, can there ever be an excess in loving him. Though in the loose sense ism may mean simply "adherence", strictly speaking even the word "Catholicism" is an oxymoron, that is, a yoking of contradictories in a compound word.

The difficulty Catholics have with Humanism is not that there is anything alien about being human, but there is something destructive—destructive of the human itself—in cutting us off from the earth whence we come and the stars, the angels and God himself to whom we go. John Donne said, "Be more than man, or thou art less than an ant." And a Catholic would add the complementary truth: Admit that you are less than angels or you will think yourself more than God.

The word human comes from the Latin *humus*, which means "earth", the same as the English word humus, the rich, organic soil in which

things grow. And in Hebrew "Adam" means "earth".

> And the Lord God formed man
> of the slime of the earth.

Humus is the root of "human", "humility" and "humor", because, knowing our humble origins, we can never take ourselves too seriously. Fanatics never laugh because they are exclusive; they think they are the only ones and, losing their sense of place, lose their sense of proportion.

The best if not the greatest of all English poets, Chaucer, writing long before the new philosophers of Humanism had broken the Catholic View of things, was able to write about the whole spectrum of angels and beasts, with all sorts of men, from saints to sinners, strung out between where everybody knew who he was and knew his place, with a genial, comprehensive, generous Catholic sanity. "Here is God's plenty", Dryden said. Chaucer saw each creature as a link in an intricate, golden chain, suspended from the love of God:

> The Firstë Movere of the cause above,
> Whan He first made the fayrë chaine of love,
> Greet was th' effect and heigh was His entente;
> Wel wyst He why and what thereof He meant.

For with that fayrë chaine of love he bond
The fyr, the eyrth, the water and the lond
In certaine boundës that they may not flee. . . .

This Catholic, universal and integral view of the human, and of everything else, can never, in the strict sense, be an ism. The Church is not a sect, cut off, living for itself. Whereas humanists isolate and ruin the very human life they hope to advance.

"My soul doth magnify the Lord", Our Lady said, "And my spirit hath rejoiced in God my Savior, because he hath regarded the humility of his handmaid." An authentic Christian Humanism would have to drop the ism and remember its foundation in the dirt.

On the other hand, the Greek word for man is *anthropos*, a combination of *ana*, meaning "upward", and *tropos*, meaning "turn"; man is the upward-turning animal who walks erect, whose head is fixed in such a way that he can see the sun and stars.

> While all the other animals are prone and look at earth, the gods gave man an up-turned face and ordered him to observe the heavens and, standing erect, to lift his countenance up to the stars.

St. Isidore of Seville in his great encyclopedia called *The Etymologies*, cites these lines of the Roman poet Ovid and comments:

Man walks erect and sees the heavens in order to serve God, not seeking to satisfy himself on earth like the animals whom God made by nature prone and obedient to their belly. Man is duplex interior and exterior. Interior a soul, exterior a body.

And the Lord God formed man of the slime of the earth and breathed into his face the breath of life, and man became a living soul.

So anthropos, the upward-turning beast, is the intelligent humus, this little piece of earth into which God breathed a living likeness of himself.

Now the word culture is generally taken to mean any arranged environment to facilitate growth. Culture in the human sense includes the artistic and moral circumstances we deliberately create. Culture as in "agriculture", the cultivation of fields, derives from the Latin *cultus* which means essentially anything subjugated, from the root *jugum*, meaning "yoke" as in "ox-yoke", the hitch connecting beasts of burden with plows; so culture is anything subjugated, put under a rule, like a yoke, and made tame. A cultivated field is subjugated to the rule of the farmer to facilitate the growth of crops; it is no longer wild; it has been plowed—which incidentally farmers often call "turned", like *anthropos*. Words connect and interconnect so fast and intricately they are like

constellations of stars. Virgil uses the Latin *vertere*, "to turn", in the opening lines of his great poem on farming, the *Georgics*, one of the capital texts of Western Culture; Dryden calls it simply "the best poem by the best poet."

> What makes the wheat rejoice, beneath what stars
> to turn the earth . . . I sing.

Virgil, along with the whole pagan and Christian tradition, thinks of culture primarily as the dignity and perfection of labor, especially in the rural life. St. Isidore defines it simply as "wheat and wine got from the earth by hard work". Many of the great Medieval Doctors of the Church, St. Bonaventure notably among them, say God wrote two books of Revelation, the Bible and the Book of Nature; and each of them must be read in the light of the other. St. Isidore says, for example, that the difference between nakedness and wearing clothes is not just the obvious physical fact, but a spiritual sign as well. Nudity is associated either with our first parents before the Fall, signifying innocence, or it signifies a second rebellion against God, who permitted us to live only on the condition of hard work, by the sweat of our brow. The fig leaf, and its development as the cincture, is a sign at once of modesty—that is, an acknowledgment of the shame our first parents

experienced as a consequence of their sin—and a sign of work, which is essentially penitential, as when it says in the Bible, "Gird up your loins", whenever there is a job to be done, as Our Lord says in the Sermon on the Mount, "Let your loins be girt and lamps burning in your hands, and you yourselves be like to men who wait for their Lord."

A larger kind of girding up is done by walls, which are large belts, as it were, around our sanctuaries, homes, workshops, fields and cities. Throughout civilized history, pagan as well as Christian, walls have been a sign of decent, safe, humane life. When Homer wants to characterize the Cyclopes, who are cannibals, all he says, with strict poetic economy, is that "they lived without walls", which might call to mind the poem by Robert Frost in which the old farmer says, "Good fences make good neighbors."

The Californian drift toward nudity, the cult of pleasure, recreation and leisure, yards without walls around them, houses without interior walls in them, are all signs of the slow, soft movement toward that second Fall, not from Paradise this time, but from work as the real basis of culture. The blurring of distinctions in philosophy and theology, attacks on the walls of private property and privacy, the loss of modesty and shame wit-

nessed day after day in the advice columns in the newspapers written by those brassy, aging prostitutes (not without a certain hard wisdom of the streets) who have become the conscience of America and who in the guise of telling Americans what "everyone is doing" expose to public gaze everything secret, terrible or tender—all these are signs in our times of a radical refusal of civilized life. If we are to restore an authentic Christian Humanism, in the wide sense of Christian Culture, we shall have to think not just about fighting infanticide, sex education and pornography, which are the front lines of secular Humanism—by all means fight them to the death—but for the positive work of the restoration of culture which lies wrecked in the wake of the humanist assault: We shall have to think about simpler, larger, elemental things which, losing their original strength, gave access to the enemy in the first place—elemental things which are the foundation and principle of the superstructures we must rebuild. We shall have to think about work, the kind of work by which we earn our daily bread, and especially farming as the only true basis of economic and social life. "God made the country, man made the town", as one poet said; or another:

> Ill fares the land, to hast'ning ills a prey,
> Where wealth accumulates and men decay.

Pius XII put it this way:

> We must recognize that one of the causes of the disequilibrium and confusion of world economy, affecting civilization and culture, is undoubtedly the distaste and even contempt shown for rural life with its numerous and essential activities. But does not history, especially in the case of the fall of the Roman Empire, teach us to see in this a warning symptom of the decline of civilization? . . . It cannot be too often repeated how much the work of the land generates physical and moral health, for nothing does more to brace the system than this beneficent contact with nature which proceeds directly from the hand of the Creator. The land is not a betrayer; it is not subject to the fickleness, the false appearances, the artificial and unhealthy attractions of the grasping city. Its stability, its wide and regular course, the enduring majesty of the rhythm of the seasons are so many reflections of the Divine attributes.

Words like these from poets and popes have fallen on deaf ears for a century. Those in universities, convinced that in statistics, charts and graphs they have reality, dismiss exhortations like these as tired clichés, never true to the ugly reality reported by economic historians and certainly out of date. As I have said so many times throughout this book, the problem isn't finding truth and stating it, but taking it seriously, listening and acting upon it.

We become the work we do. If farming reflects Divine attributes, farmers through their work become something like God. Appearances are not only signs of reality but in a sense are like sacraments; they effect what they signify. I mean that there is a cause-effect relation between the work we do, the clothes we wear or do not wear, the houses we live in, the walls or lack of walls, the landscape, the semiconscious sights, sounds, smells, tastes and touches of our ordinary lives—a close connection between these and the moral and spiritual development of souls. It is ridiculous but nonetheless true that a generation which has given up the distinction between fingers and forks will find it difficult to keep the distinction between affection and sex or between a right to one's body and the murder of one's child. If you eat ketchup-smeared French fries with your fingers day after day, you are well on your way to the Cyclops. The semiconscious, ordinary actions which come under the category of manners are the cultural seed-bed of morals, as morals in their turn are of the spiritual life. We are creatures of habit, as the nuns used to say. In the moral and spiritual order, we become what we wear as much as what we wear "becomes" us—and it is the same with how we eat and what we do. That is the secret of St. Benedict's Rule which in the strict sense regulated

monasteries and in the wider sense, through the influence and example of monasteries, especially in their love of Our Blessed Mother, civilized Europe. The habits of monks, the bells, the ordered life, the "conversation", the music, gardens, prayer, hard work and walls—all these accidental and incidental forms conformed the moral and spiritual life of Christians to the love of Mary and her Son. Modern architecture, to take a striking example, has worked to disconform us from the love of God.

The modern movement in architecture was introduced into the United States in the twenties and thirties by refugees from the Bauhaus, an experimental apartment complex in Berlin, designed and built before the Nazi Putsch by Marxists for a revolutionary workers' commune, a sort of communist kibbutz. The purpose was to conform the inhabitants to Marxist doctrine, and it is an irony worthy of C. S. Lewis's Screwtape to think of New York financiers building their skyscraper office buildings according to communist prescriptions—and even Screwtape must have been amazed to see those principles being applied to Catholic churches! The best-selling writer Tom Wolfe, from a smart, superficial but accurate survey, has exposed the destructive consequences of Marxist architectural kitsch on the whole of

American life in his book *From Bauhaus to Our House*.

Of all the suicidal worms gnawing at the vitals of the so-called postconciliar Church, one of the most destructive is cultural pluralism, which is a self-contradictory reversal of the dictum stamped on our money, *e pluribus unum*, into *ex uno plures*. If Sunday after Sunday congregations assist at the Holy Sacrifice of the Mass in churches built to the standards and specifications of Hamburger Heaven, it won't be long before the faithful have departed from the Faith, ripe for liturgical innovations like the consecration of Coca-Cola and potato chips.

But can there be a legitimate Christian Humanism? The status of the question, as the classical debaters say, is "definition". It is only possible to judge whether Humanism or any cultural development is compatible with the Catholic Faith if you know what these developments are. To summarize and then proceed: because a Catholic can never be sectarian, and adhere to a cause, person or thing exclusively and to excess, he cannot be a Humanist in the strict sense; but there can be and has been a Catholic culture which is sometimes called Catholic or Christian Humanism. The word culture derives from the Latin *cultus*, as I said, meaning essentially a set of actions

designed to subdue, that is to subject to a rule. As agriculture is the cultivation of fields, in religion *cult* is the performance of prescribed actions designed to subdue a people to the wishes of its god, as the cult of Apollo or Isis among pagans and the cults of Christ, his Blessed Mother and the angels and saints among ourselves.

Religion is not sentiment or public or private enthusiasm; it is a species of justice, and justice is defined as "paying to each his due". Justice is always depicted holding scales because the payment of debts requires equality—we must pay back exactly what we owe. Now, there are certain kinds of debt which can be paid only in part, up to our ability, because they are beyond measure in themselves and beyond our natural capacities—for example, the debt we owe our parents for giving us life and to God for existence. We cannot give life to our parents even if we were to sacrifice ours in saving them; we cannot give God existence because he is existence in himself and we cannot give him what he has, nor could we give existence anyway because we have no creative power to do so; our nature is not such as to create, *ex nihilo*, something from nothing. So this kind of debt can only be paid by what is called relative justice in which, as in the parable, we give the widow's mite—we give as much as we can out of the nature

we have. The virtue of *piety* is the species of relative justice by which we honor our parents in return for the debt of life; and *religion* is the species of relative justice by which we honor God as Creator and Lord. Since these debts are incommensurable with any payment in kind, we return them in the coin of *honor*, which is defined as the acknowledgment of excellence. Honor may be paid to anyone for a job well done, but when in particular it is given by those who are subject to the one they honor, as children are subject to parents, citizens to the nation, the human race to God, then the honor is paid according to prescribed forms by which we acknowledge both the excellence and our subjection, and this is the formal definition of *cult*. There is a civil cult of one's country in official acts such as pledging allegiance; there is the domestic cult of giving formal honor to parents, for example when parental consent is asked for in marriage; and there is the religious cult among Catholics centered in the Eucharist and including the cults of Our Blessed Mother and of angels and saints.

Cult is the basis of culture. An authentic Christian culture, therefore, must be centered on an authentic Christian cult.

These terms are technical, so let me repeat: Religion is the species of relative justice by which

we do our best to pay the incommensurable debt due to God for our existence; it is paying the debt of honor to our ultimate superior for his supreme and infinite excellence in officially prescribed forms called cults. The different kinds of cult are diversified by degrees of excellence in the person honored; God himself is always the principal object of the Christian religious cult. By principal I mean that he is always the object, obviously when the cult is offered directly to him, but though less obviously, it is nonetheless offered indirectly to him through secondary cults to angels and saints, because the excellence we honor in angels and saints is the excellence of grace which is actually his presence in them. Since there is one God alone, the cult directly due him is unique; theologians call it the cult of *latria*. If the cult of latria is given to anyone or anything other than God, that is a sin against religion, which is the technical definition in theology of *superstition*; and its cult is called idolatry—*idol*, the anglicized form of *eidolon*, meaning false, empty, vain image; and *latry*, the anglicized form of *latria*. An idol, St. Paul says (1 Cor. 7:4) is "nothing in the world"; so idolatry is the superstitious offering of the cult of latria to anyone or anything other than God, and it is forbidden according to reason and expressly in the First Commandment. But God

can be indirectly honored in his angels and saints because he is present in them by grace and therefore there is another species of cult called by theologians *dulia*.

And what of Our Blessed Mother? Should she be given the cult of dulia in the highest degree because she is full of grace? There has been a family quarrel among theologians about this, but by a large consensus of doctors, councils and popes, as well as by the testimony of liturgy and common belief—the *sensus fidelium*—it would be rash and temerarious to deny that Mary is a special case. Excellence is the result of action, and actions are measured by their results. The term of Mary's most important action—her pregnancy—was the hypostatic union, the union of God and man; and so not just by grace as in the angels and saints, but in her very nature, the Blessed Virgin touched the infinite. A cell of her body, united with an action of the Holy Ghost, became Christ, true God and true man; and so in her nature she was taken up into a participation in the life of God which the saints and angels share only by the added habit of sanctifying grace, becoming sons by adoption. The cult of first, highest and most important dulia (theologians call it protodulia, from the Greek *proto*, meaning first) most probably is due to St. Joseph because as Our Lady's husband he is spiri-

tually "one flesh" with her and as Our Lord's
adoptive father he is his closest adopted son; some
say St. John the Baptist because Our Lord said,
"There hath not risen among them that are born of
woman a greater than John the Baptist." Leo XIII
seems to have settled the question in his encyclical
Quamquam pluries:

> The dignity of the Mother of God is so elevated
> that there can be no higher created one. But since
> St. Joseph was united to the Blessed Virgin by
> the conjugal bond, there is no doubt that he ap-
> proached nearer than any other to that super-eminent
> dignity. . . .

Garrigou-Lagrange from whom I have taken most
of this material discusses all these questions in
his brilliant and religious book *The Mother of the
Saviour*.

But Mary is the real, not the adoptive, mother
of God, and therefore the cult of what the theo-
logians call hyperdulia is due to her alone; *hyper*,
as we commonly know from its medical uses,
means "above", "in an eminent degree". It is not
"Mariolatry", not the cult of latria, as Protestants
have thought, which would be superstition, but
hyperdulia, a unique and higher dulia, due to her
as Theotokos, Mother of God, which is her chief
excellence, greater even than her plenitude of

grace and the root reason, though not the proximate cause, of her Assumption.

Because Our Blessed Mother is the Mother of God, Jesus owes her the debt of relative justice called piety, by which he honors her excellence and obeys her every wish, which because of her perfect love for him can never be other than what he wishes anyway. It staggers the imagination—though not the intelligence—to think that Jesus owes honor and obedience to Mary in the debt of his nature as man to his natural mother, though not of his nature as God. But the mystery of the Incarnation resides in the hypostatic union of those two natures in one person, and it follows that every cell of Christ's body, each cell of the Eucharist, is a multiplied division of an original cell of hers still living on in these forms. And it follows that her powers are not merely intercessory, like those of St. Joseph and the angels and saints. All grace distributed in time through the Eucharist comes to us, as the Eucharist itself does, through her, Mediatrix of all grace. And because of this, the cult of Mary touches the infinite. St. Bernard said of her, *de Maria nunquam satis* "Concerning Mary there can never be enough!" In fact she has all her Son's prerogatives as Lord save one: He has reserved to himself the Judgment. Perhaps because there is such apparent opposition between

justice and mercy—there can be no contradiction in the mind of God between them; but perhaps since it is difficult for us to reconcile them—Christ has given the one to his Blessed Mother and reserved the other to himself. Whatever the reason, Mary is certainly the Mother of Mercy and not just morally through her intercession, but in her nature as Mother of God. According to St. Odilo of Cluny, her mercy and her nature are so united that when she was assumed into Heaven a physical shock went through the universe and the pains of Hell were momentarily suspended; and he thinks that in commemoration there is some degree of respite for the damned each year on the Feast of the Assumption.

St. Alphonsus Liguori says that when the Bridegroom cries to his Beloved in the Canticles, "Feed your goats!" it means the Holy Ghost, who is the Groom, gave to Mary, his bride, the power to feed even sinners with his saving grace. As we know, Christ says the "goats" will be divided from the "sheep" at the Judgment, so the goat is a figure for the lost; but not all sinners will be lost because the Holy Ghost says, "Feed *your* goats", which means, according to St. Alphonsus, those who belong to her, those sinners who despite their sins have a sincere desire to amend them and a devotion to her during their lives. These—her

goats—even though they have remained in sin right up to the instant of death and in all human judgment must be lost, will at the last instant be given the grace of receiving the last sacraments or of perfect contrition, which is a good reason for reflecting again on the theological exactitude and richness of every word in her greatest prayer: "Holy Mary, Mother of God, pray for us sinners now and *at the hour of our death*. Amen." Of course, St. Alphonsus warns us, she will not be mocked; we must not abuse her love in presumptuous sin; but he says, so simply that we might miss the magnitude of the statement,

> It is impossible for a client of Mary who is faithful in honoring her and recommending himself to her, to be lost.

So I shall answer the question I began with—is there a Christian Humanism—by saying in the strict sense no, because no Catholic can adhere exclusively and excessively to any creature; that would be a sin of superstition and its practice the cult of idolatry, an inordinate act of mistaken religion in which the cult due to God or his Blessed Mother were given to anyone less.

Only God is infinite in nature; but because her nature touched the infinite in conceiving him, the cult of Mary is not idolatry. Humanism in the

strict sense cannot be Christian. But in the wider sense, taken to mean culture, the cultivation of the physical, moral and spiritual soil in which humans grow, there can be and in fact has been a Christian Humanism, and though it may be a scandal to the secular historians and a surprise to the Catholics to put it this way, authentic Christian Humanism, more properly Christian Culture, has been in fact nothing more nor less than the cult of the Blessed Virgin Mary.

The whole great culture of the thousand years when Europe was so deeply infused with Christ that Belloc's famous aphorism was true—"the Faith is Europe, Europe is the Faith"—from the fifth to the fifteenth century when the Renaissance cut the human off from its roots in the humus and its flowering among the stars—for a thousand years there was a thing called Christendom and its culture was the cult of Mary, founded in the humus of her humility assumed into Heaven, drawing us up.

It is always impressive in arguments like this when a Catholic might be accused of exaggeration and special pleading, to get a non-Catholic witness to the Catholic truth. When one of the best American historians (certainly the most reflective and philosophical)—not a Catholic, but a secular pessimist who like a latter-day Hamlet had seen

through the empty promises of Humanism, Henry Adams, wanted to sum up the difference between Christian Culture and secular Humanism, he hit upon the famous contrast between the Virgin and the Dynamo. The entire culture of Christendom, he said, flowering in the Middle Ages when the spirit of Christ informed all aspects of life down to the smallest detail, from the roughest popular barrack ballads and shepherd's songs to the subtlest and most intricately balanced arches of Gregorian chant, from the rudest country crossroad Cross to the glorious complexities of the great Gothic cathedrals like the one at Chartres, from brawling disputations in the student-quarter bars in Paris to the constellated brilliance of the *Summa Theologica*, among saints and sinners alike, in architecture, warfare—which was known as chivalry—politics, economics, music, poetry, in both peasant and courtly love, in all the rough and delicate manners of the cottage and court—the whole culture was in fact simply the cult of Mary; it was all for her. And in our time, in the reign of science and technology, Adams said, culture is nothing but the cult of dynamos—symbols of mindless, loveless, force. Secular Humanism is the worship, not really of man as it might seem from the word, but of man-made things. We worship our instruments. Karl Marx generated his whole theory of history

from the idea that we are determined by our technology, which he called the means of production; whereas Christian Humanism, more properly Christian Culture, is the human use of instruments in the service of the Blessed Virgin Mary.

Henry Adams visited the Great Exposition of Science and Industry which ushered in the twentieth century at Paris in 1900 with his friend the astronomer Langley, one of the inventors of the airplane. Writing about himself in the third person, Adams says,

Nothing in education is so astonishing as the amount of ignorance it accumulates in the form of inert facts. Adams had studied Karl Marx and his doctrines of history with profound attention, yet he could not apply them at Paris. Langley, with the ease of a great master of experiment, threw out of the field every exhibit that did not reveal a new application of force. . . . He led his pupil directly to the forces. His chief interest was in new motors to make his airship more feasible, and he taught Adams the astonishing complexities of the new Daimler motor, and of the automobile which since 1893 had become a nightmare at a hundred kilometers an hour. . . . Then he showed his scholar the great hall of dynamos. . . . To him the dynamo was but an ingenious channel for conveying somewhere the heat latent in a few tons of poor coal . . . but to Adams it became a symbol of infinity. As he grew accustomed to the

great gallery of machines, he began to feel the forty-foot dynamo as a moral force, such as the early Christians felt the cross. The planet itself seemed less impressive, in its old-fashioned, deliberate, annual or daily revolution, than this huge wheel, revolving within arm's-length at some vertiginous speed, and barely murmuring—scarcely humming an audible warning to stand a hair's-breadth further for respect of power—while it would not wake the baby lying close against its frame. Before the end, one began to pray to it; inherited instinct taught the natural expression of man before silent and infinite force.

It isn't necessary to document how much our music, architecture, poetry, art from Picasso, Stravinsky and the Bauhaus to the popular stuff like *Star Wars*, are idolatries of force. With astonishing prophetic insight, Henry Adams saw the whole twentieth century laid out before him like a map and he saw with equal clarity that once things had been exactly opposite, infinitely better and more beautiful.

At the Louvre and at Chartres, as he knew by the record of work actually done and still before his eyes, was the highest energy ever known to man, the creator of four-fifths of his best art, exercising vastly more attraction over the human mind than all the steam-engines and dynamos ever dreamed of; and yet this energy was unknown to the American

mind. . . . All the steam in the world could not, like the Virgin, build Chartres. Symbol or energy, the Virgin had acted as the greatest force the Western world had ever felt, and had drawn men's activities to herself more strongly than any other power, natural or supernatural, had ever done; the historian's task was to follow the track of this energy; to find where it came from and where it went to; its complex source and shifting channels; its values, equivalents, conversions.

Of course he attempted the impossible; he tried to track the energy and force of Mary without the secret of her grace and nature; and without the love of her Son and therefore without any love or understanding of her—as if she were a force and as if scientific method could track her!

The book that resulted from his quest is nonetheless remarkable for its insights, as well as its errors. *Mont Saint Michel and Chartres* is a masterpiece of secular pessimism, which, seeing through the vanity of secular Humanism, stands in sad awe, like the fallen angels, before the love which moves the stars. Adams says of Chartres that,

to the Church, no doubt, its cathedral here has a fixed and administrative meaning, which is the same as that of every other bishop's seat . . . but to us, it is a child's fancy; a toy-house to please the Queen of Heaven—to please her so much that she would be happy in it, to charm her till she smiled.

The Queen Mother was as majestic as you like; she was absolute; she could be stern; she was not above being angry; but she was still a woman, who loved grace, beauty, ornament—her toilette, robes, jewels; —who considered the arrangements of her palace with attention, and liked both light and color. . . . She was extremely sensitive to neglect, to disagreeable impressions, to want of intelligence in her surroundings. She was the greatest artist, as she was the greatest philosopher and musician and theologist, that ever lived on earth, except her Son, who at Chartres is still an Infant under her guardianship. . . . This Church was built for her in this spirit of simpleminded, practical, utilitarian Faith—in this singleness of thought, exactly as a little girl sets up a doll house for her favorite blonde doll. Unless you can go back to your dolls, you are out of place here. If you can go back to them, and get rid for one small hour of the weight of custom, you shall see Chartres in her glory.

And that, Adams says, is not just true of the great Cathedral in France, which is its highest expression in stone, but of Christian Culture absolutely everywhere, wherever it has been or will be, on earth. Mary is its cause, effect and measure. The Devil's name is legion and his doctrine pluralism. And the Blessed Virgin Mary hates him, his doctrine and the architecture of his dark, satanic mills. So we must ask ourselves about our churches and

our liturgies, our cities, schools and homes, do they please the Blessed Queen of Heaven and Earth, who is so sensitive to light and color and neglect, to disagreeable impressions and want of intelligence in her surroundings? And, above all, within our hearts, what sort of rooms have we prepared for her where she might come and visit with her Son? Each article of clothing we wear, each game we play, each line we write, each experiment, conversation, business deal or vote is hers. Technological and historical research confirm what popular piety always knows and what the clear message of the recent private revelations given official sanction by the Church has reconfirmed, especially at Fatima. That is, theology and popular piety agree that Christendom will be restored only when a determinate number of hearts are consecrated to the Immaculate Heart of Mary. Pius XII consecrated the world to her Immaculate Heart in 1942 when Hitler's armies threatened the exterior and extended Church; John Paul II at Fatima in 1982 has explicitly repeated that significant pontifical act; and it is our first task, if we would work with him as Catholics for the restoration of the Church which is threatened now by a more insidious, interior apostasy, to consecrate our homes, schools, parishes and hearts to her.

It is not certain but the more probable view—the signs of the times seem clear—is that the angel of death is passing over us right now in these final decades of the most shameful century in history. The time of the chastisement prophesied at Fatima is, I think, now. It is not something to expect but rather to recognize. The Holy Father has been shot and almost garroted, a loud if not the larger part of the Church in America and elsewhere is in material if not formal rebellion against the magisterium. There is widespread disobedience to the ordinary teachings of *Casti Connubii* and *Humanae Vitae*; the polls show very little statistical difference between the opinions and practices of Catholics, as opposed to Humanists, on contraception, divorce, infanticide and even unspeakable vice. There has never been a holocaust in history like the annual murder of a million and a half of our children in the United States. And worse, in the spiritual order, the norms for the celebration of the greatest act in the universe, the Holy Sacrifice of the Mass, are trifled with *ad libitum*.

Among Our Blessed Mother's many great prerogatives is Hope—she is our life, our sweetness and our Hope. And even now, as once in the darkness of Egypt, when the Hebrew families painted their houses with the sacrificial blood of lambs, she is moving by the doorposts of our

hearts, painting them with the Precious Blood of her Son.

Of course we shall nonetheless rise in the morning, breakfast and go to work; life persists in the midst of crises; Our Lady's apparitions such as those at La Salette, Lourdes and Fatima, urging us to prayer and sacrifice, must not be misunderstood as advocating Quietism. Quite the contrary, one of the homely truths they clearly set forth is that great historical change takes place in out of the way places while the world goes on about its business on the center stage. Again, as in the case of Henry Adams, let me take a sophisticated secular Humanist as a witness to the Faith, who sees so clearly what he somehow can't believe. Living as far from the Virgin Mary as you can get, this particular poet was nevertheless moved at least a significant step toward her by a striking intuition. W. H. Auden describes how artists have depicted the decisive events such as Our Lord's Nativity and Passion and the martyrdom of saints, filling in the background and sometimes the foreground of the paintings with what seem to be irrelevant figures—but that is just the point:

> About suffering they were never wrong,
> The Old Masters; how well they understood
> Its human position; how it takes place

While everyone else is eating or opening a window
 or just walking dully along;
How, when the agèd are reverently, passionately
 waiting
For the miraculous birth, there always must be
Children who did not specially want it to happen,
 skating
On a pond at the edge of a wood:
They never forgot
That even the dreadful martyrdom must run· its
 course
Anyhow in a corner, some untidy spot
Where the dogs go on with their doggy life and the
 torturer's horse
Scratches his innocent behind on a tree.

And in the second part of the poem, Auden refers
to a famous painting depicting the myth of Icarus,
the boy whose father made him wings out of wax
and feathers, but the rebellious adolescent in his
arrogance flew too near the sun which melted
the wax, and he pitched to his death in the sea.
The chief point of Breughel's interpretation of the
myth is that the event, celebrated for thousands
of years in poetry and art, was not, you might
say, reported on television; it went unnoticed at
the time and even at the place. We must never
make the mistake of thinking that significance is
measured by the media:

In Breughel's *Icarus*, for instance, how everything
 turns away
Quite leisurely from the disaster; the ploughman
 may
Have heard the splash, the forsaken cry,
But for him it was not an important failure; the sun
 shone
As it had to on the white legs disappearing into the
 green
Water; and the expensive, delicate ship that must
 have seen
Something amazing, a boy falling out of the sky,
Had somewhere to get to and sailed calmly on.

So of course we shall go on with our human life
and scratch our less innocent selves as we wait
for the end. I am not suggesting that we hide
in cellars, hoarding survival stocks against the
coming of Antichrist. Quite the contrary. "Let
your loins be girt and lamps burning in your
hands; and you yourselves be like to men who
wait for their Lord." We must get calmly on with
our work and our taxes, redeeming the time in
our station in life, even while the miraculous birth
and the martyrdom occur, "anyhow in a corner",
perhaps in some unlikely Bethlehem like our own
backyard. There may be someone reading these
words right now who, like St. Margaret Mary or
St. Catherine Labouré—unknown as yet to herself

—is the focal point of a great historical change. All over the world at this very hour, Mary and her angels are moving among the human race. If we consecrate our hearts to hers we shall be among those who make a difference.

Mary's love is first of all directed to her priests, who are of first importance because in a sense the Eucharist is the Church itself, and the priest its indispensable instrument; but secondarily her love includes religious and laity who assist at the Sacrifice; and even the least among us, troubled by sins and failures, will share this splendid moment in the history of the Church because not only his sheep but *her* goats are called—for whom, if we love her, somehow, anyhow, in a corner, a marvelous Child will fall out of the sky and she will make us subject, subdue us, to his will despite the Darkness of Egypt and the darkness in ourselves.